POSH® COLORING BOOK
Cats & Flowers
for Fun & Relaxation

copyright © 2017 by Susan Black. All rights reserved. Printed in the United States of America. No part of this book may be used or reproduced in any manner whatsoever without written permission except in the case of reprints in the context of reviews.

Andrews McMeel Publishing
a division of Andrews McMeel Universal
1130 Walnut Street, Kansas City, Missouri 64106

www.andrewsmcmeel.com

18 19 20 21 22 MLY 10 9 8 7 6 5 4 3

ISBN: 978-1-4494-8199-5

ATTENTION: SCHOOLS AND BUSINESSES
Andrews McMeel books are available at quantity discounts with bulk purchase for educational, business, or sales promotional use. For information, please e-mail the Andrews McMeel Publishing Special Sales Department: specialsales@amuniversal.com.

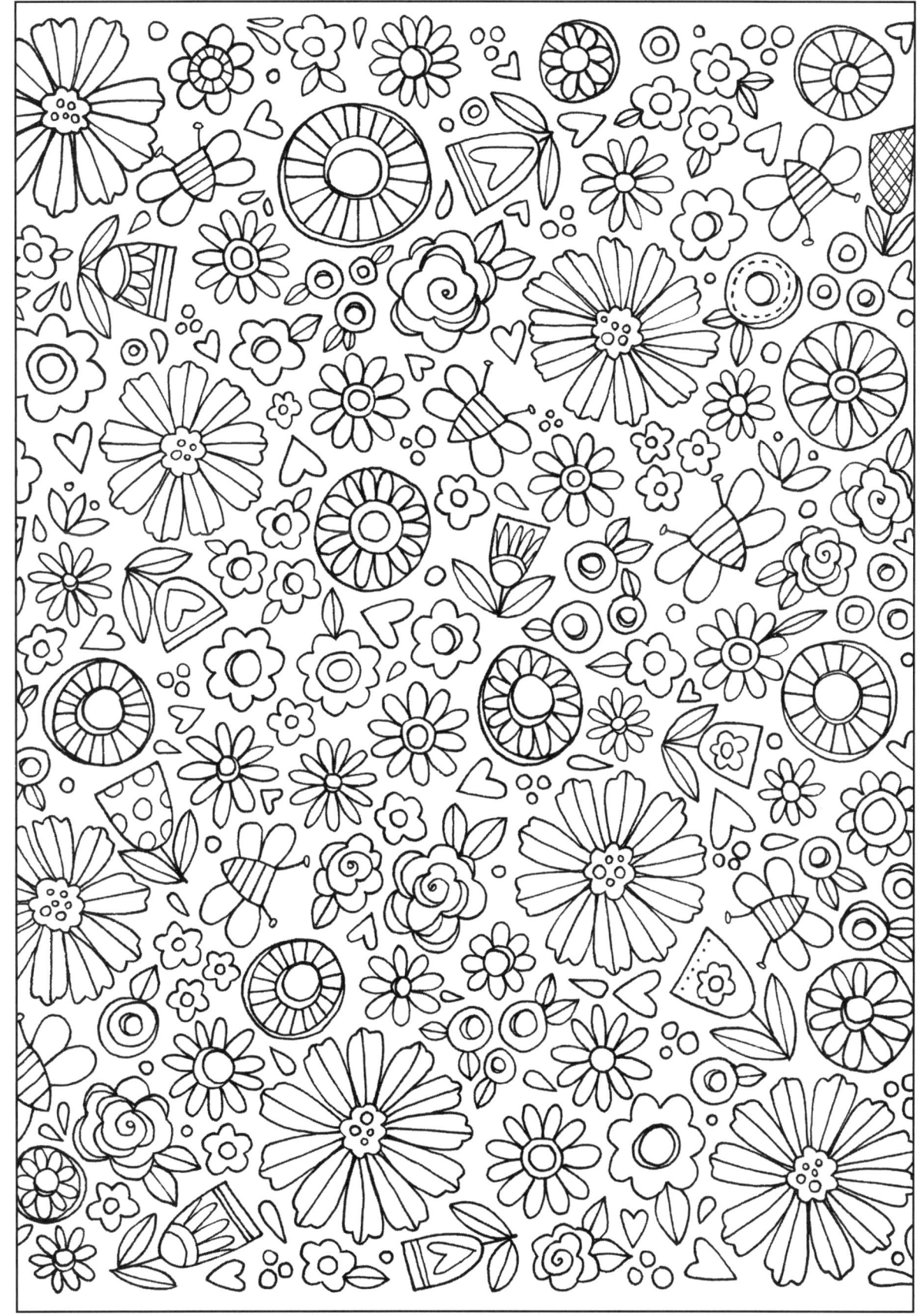

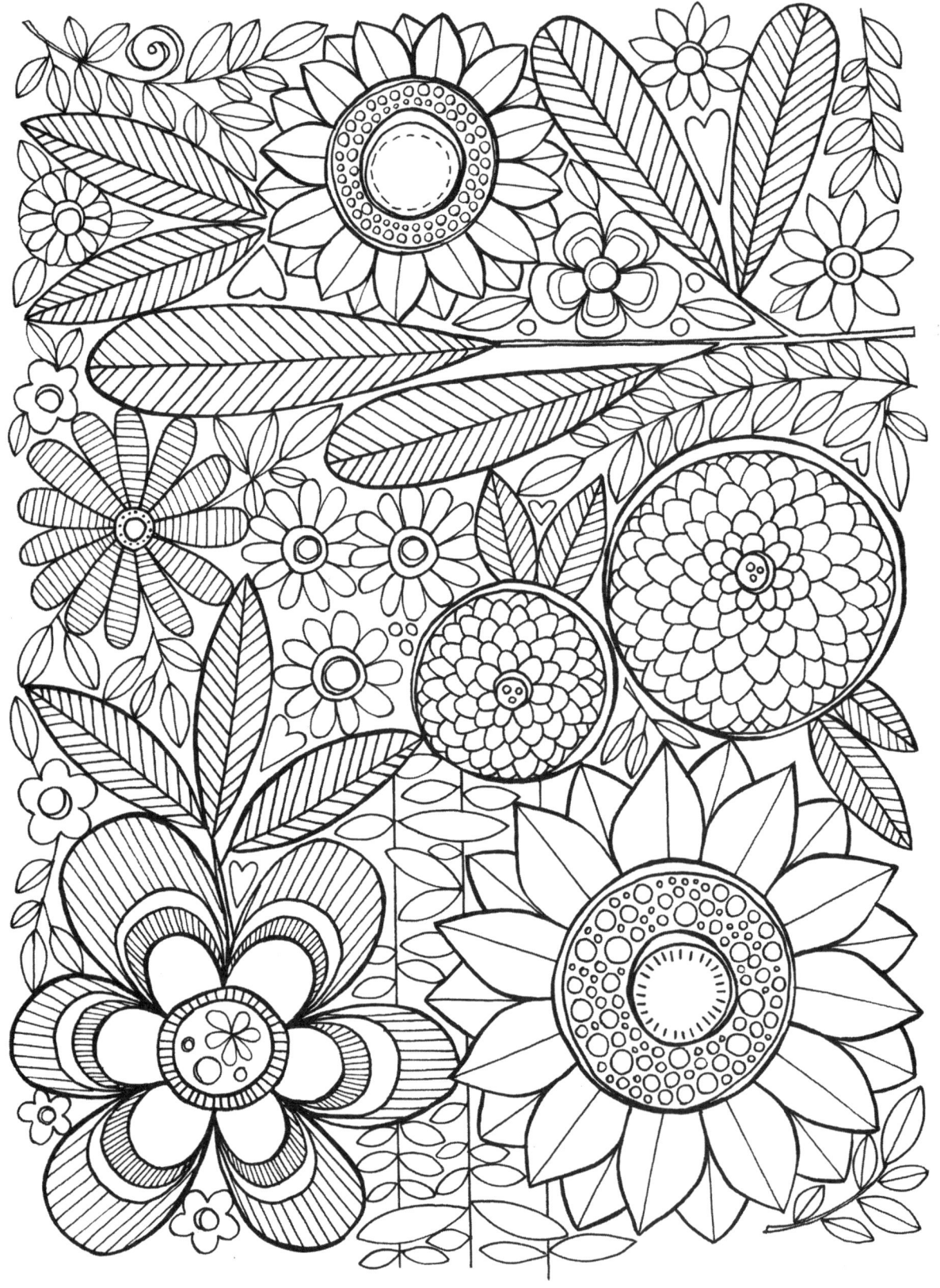

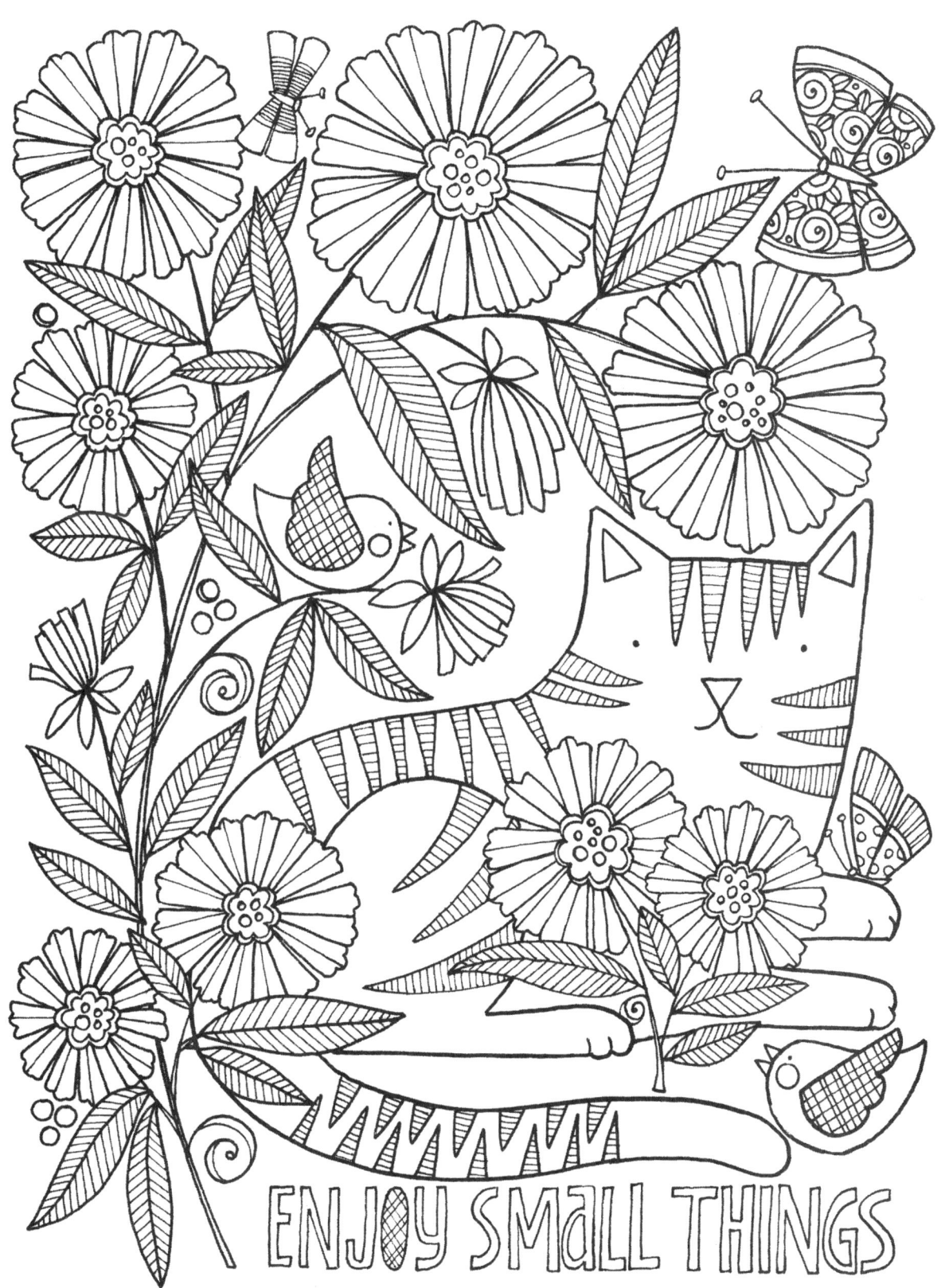

YOU HAVE CAT TO BE KITTEN MEOW

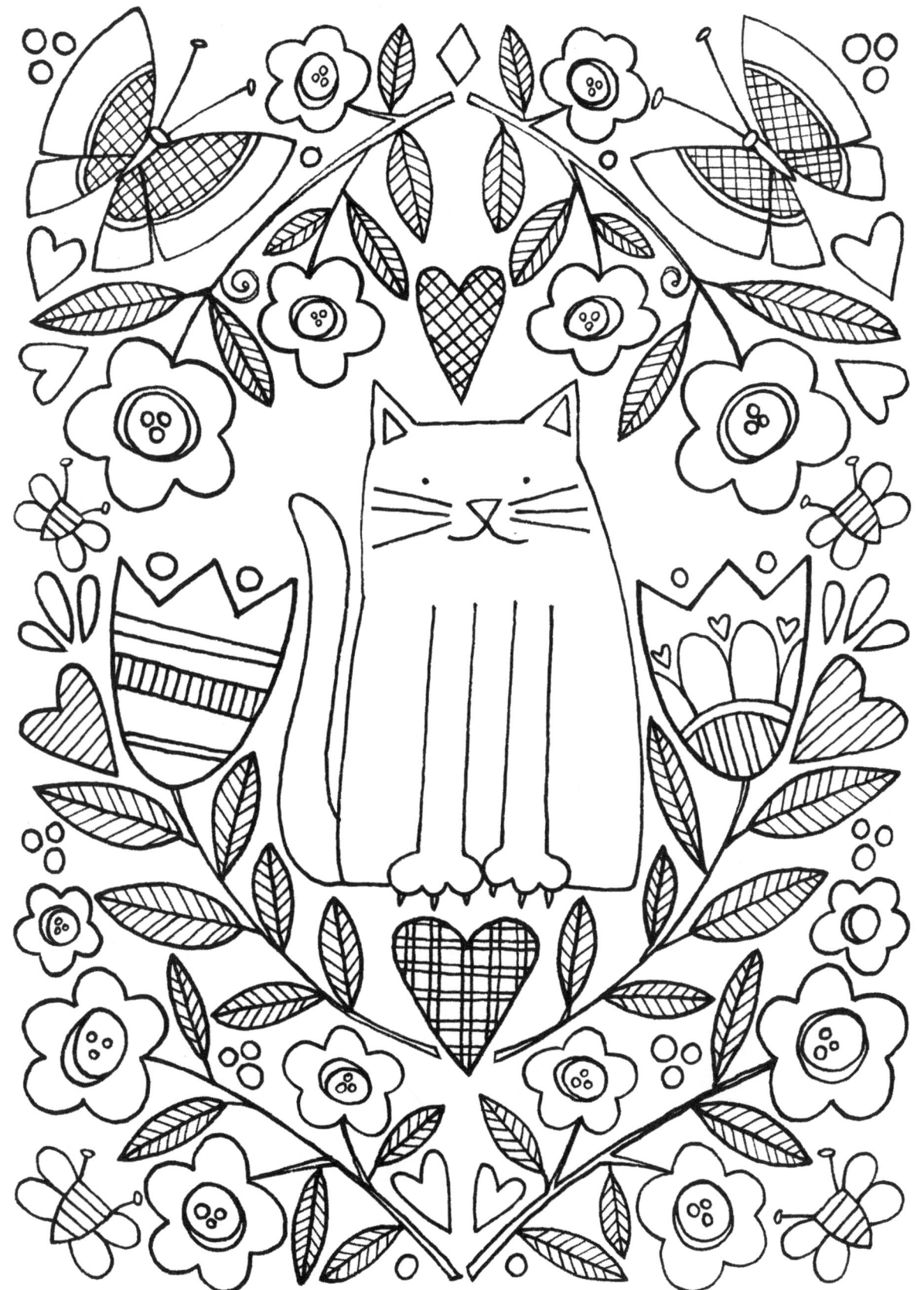

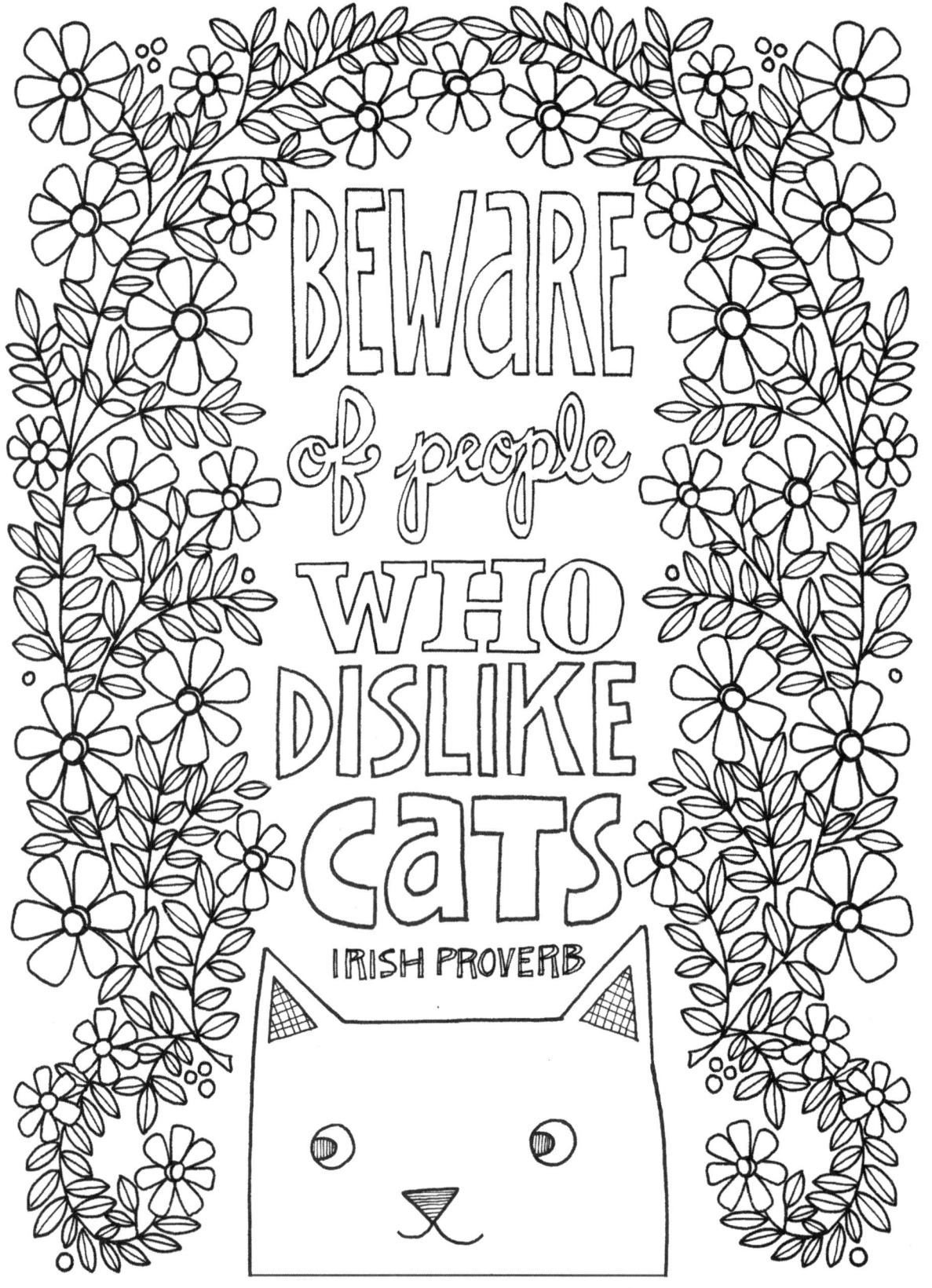

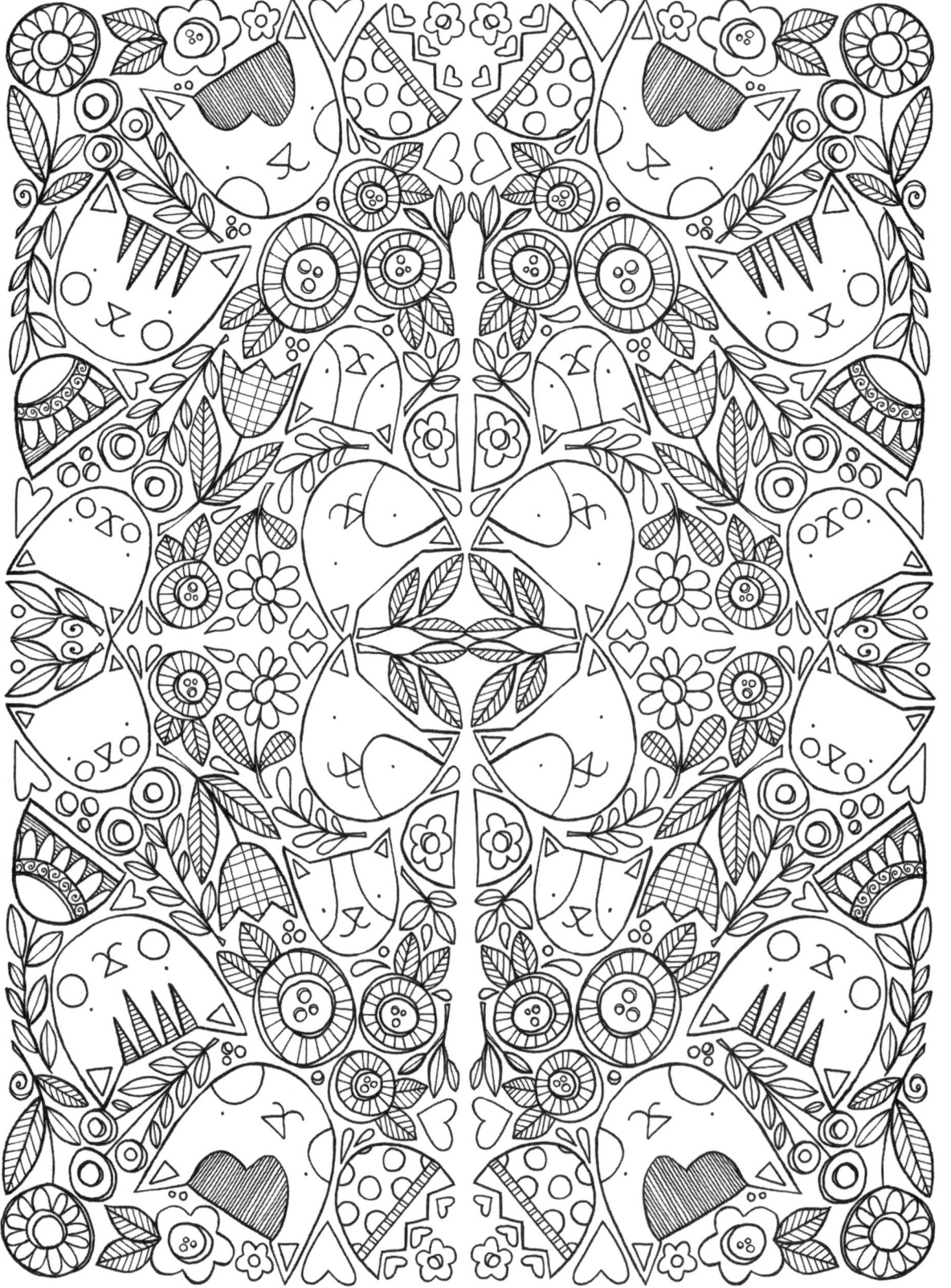

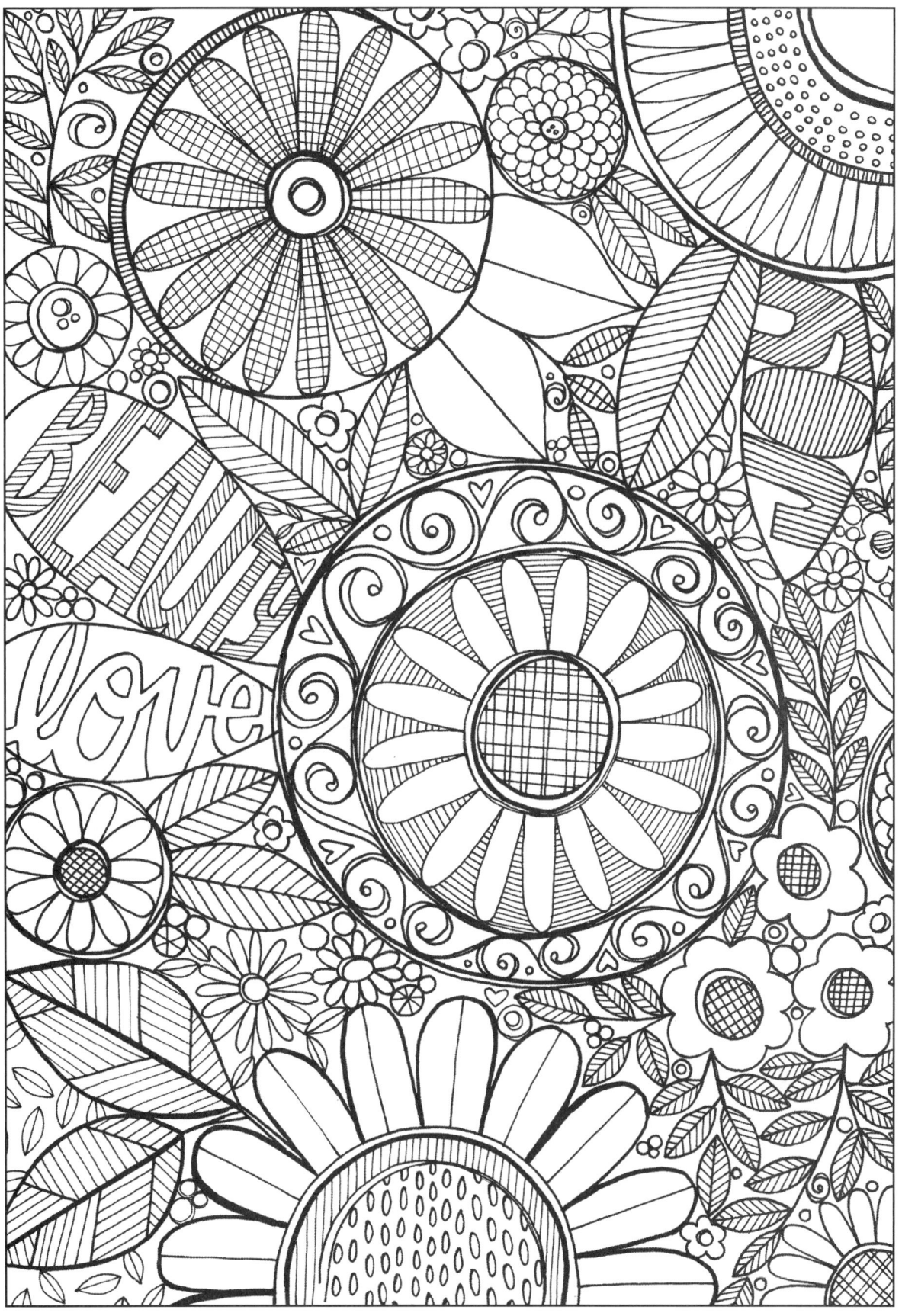

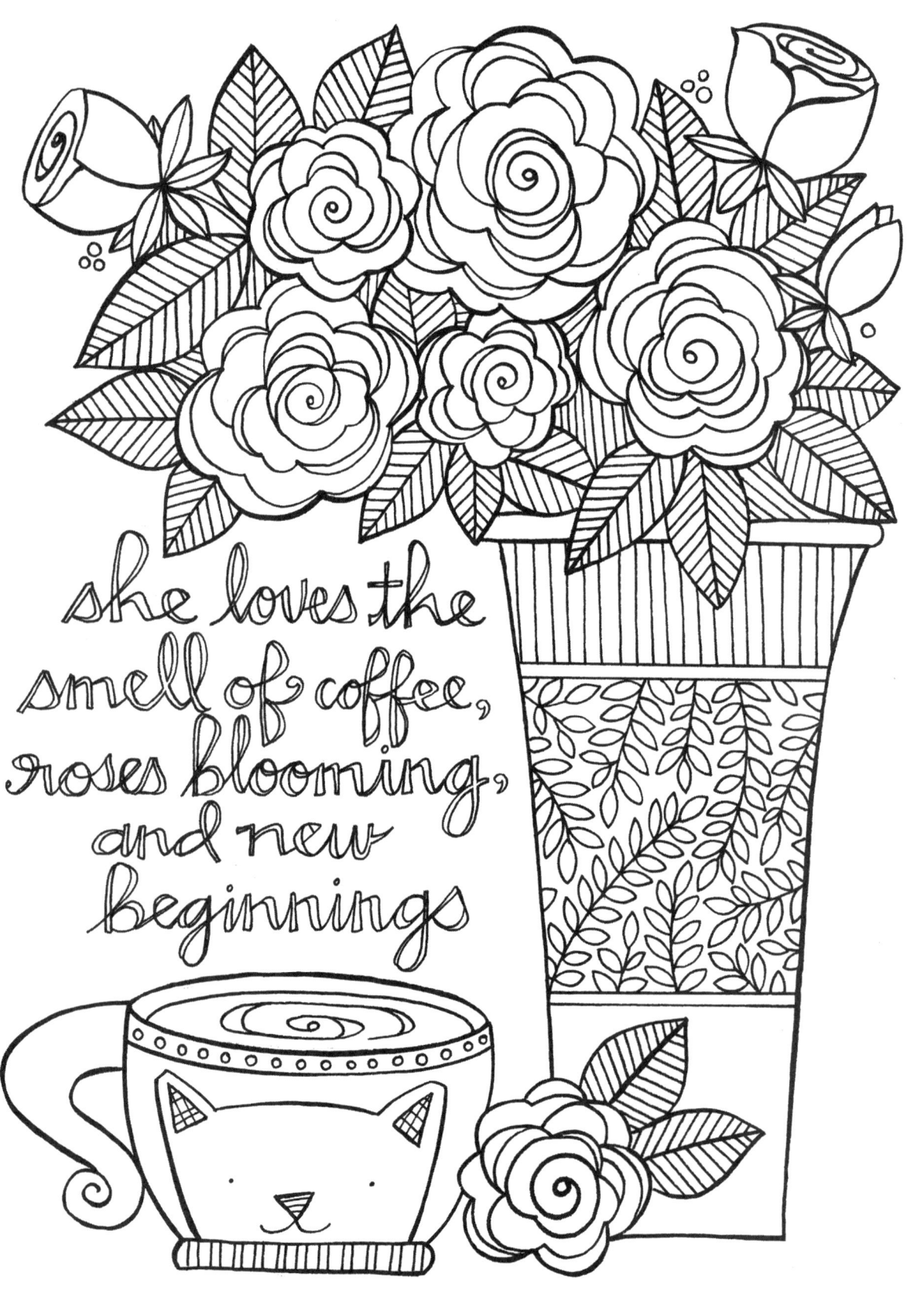

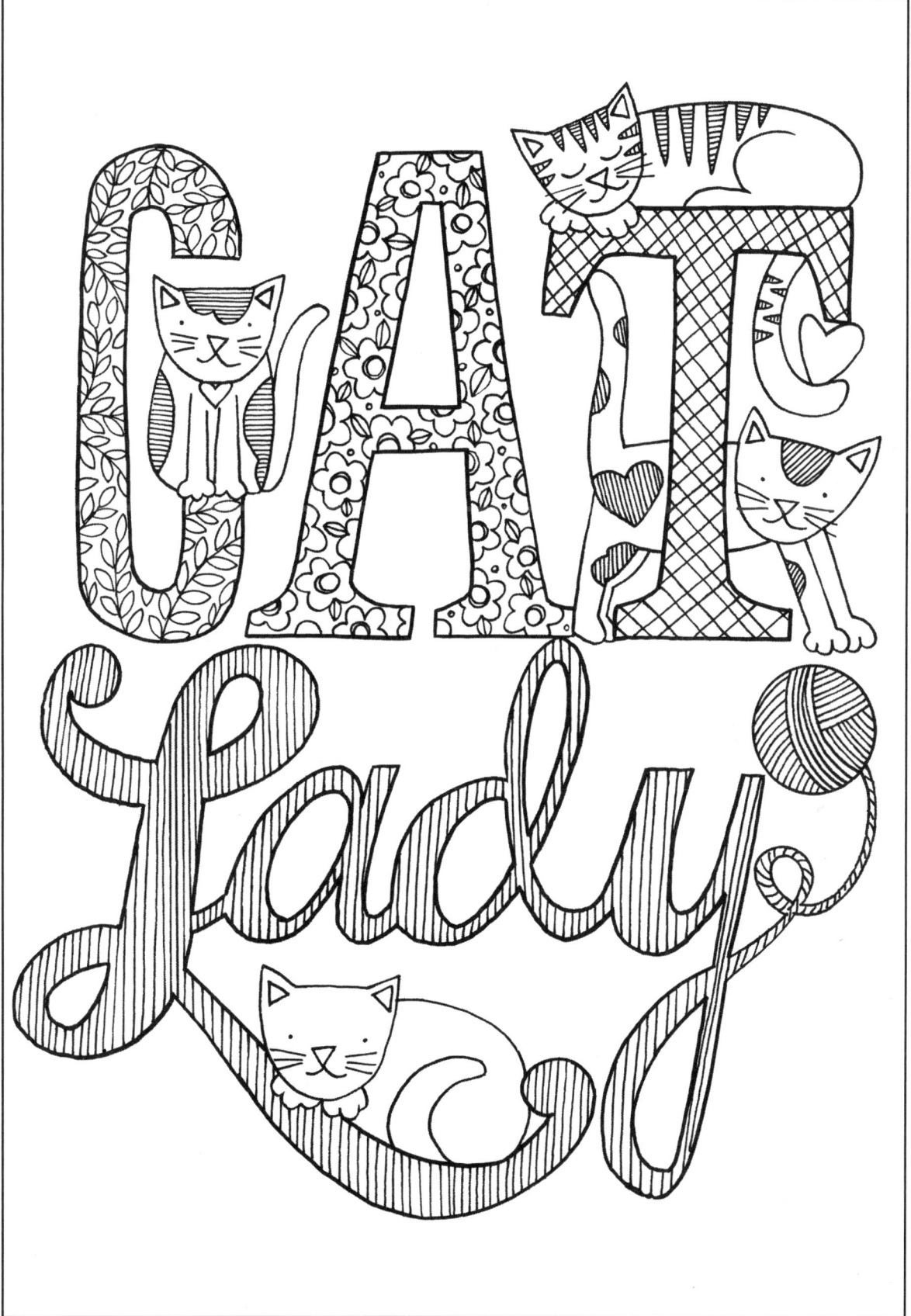

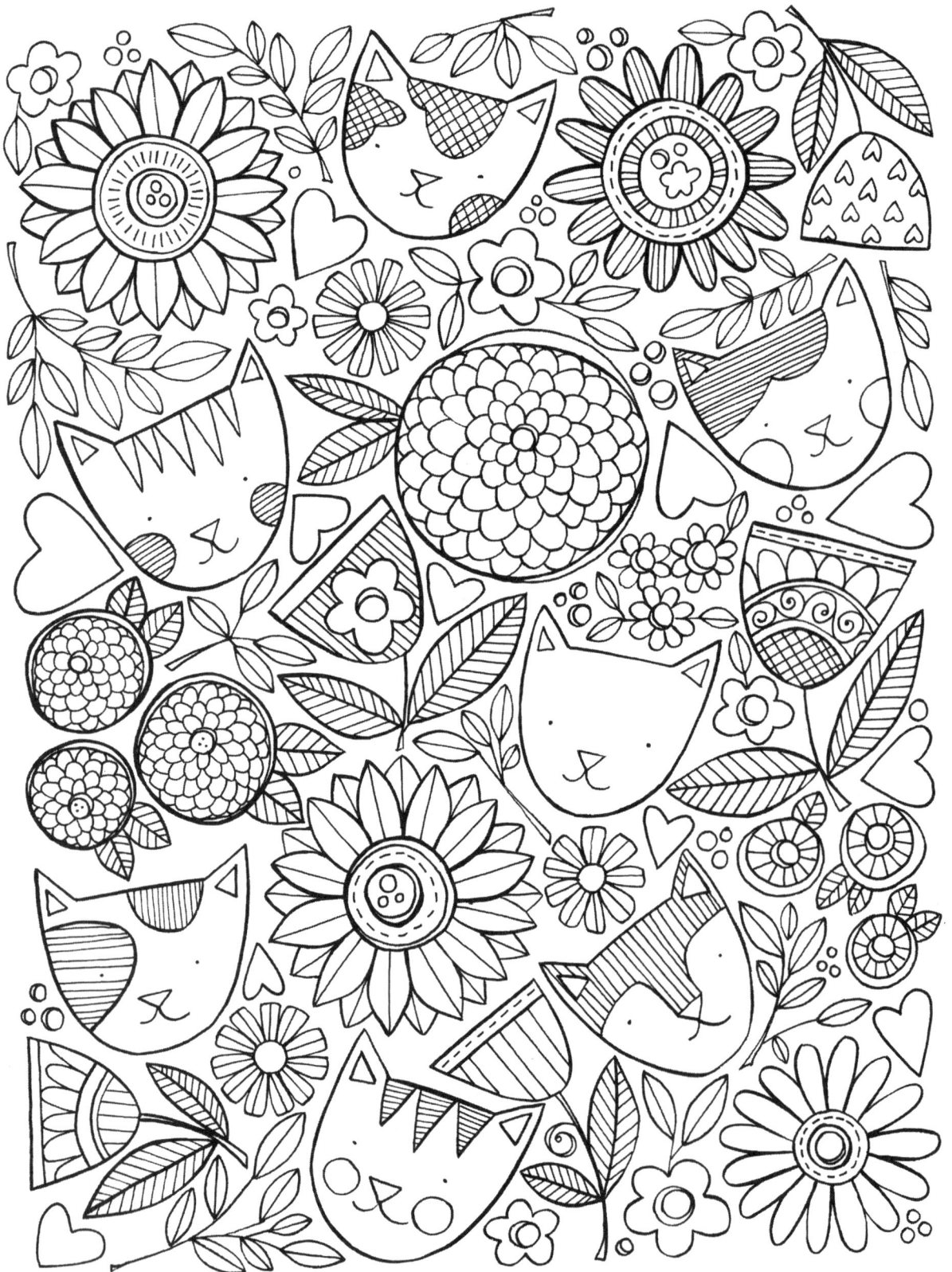

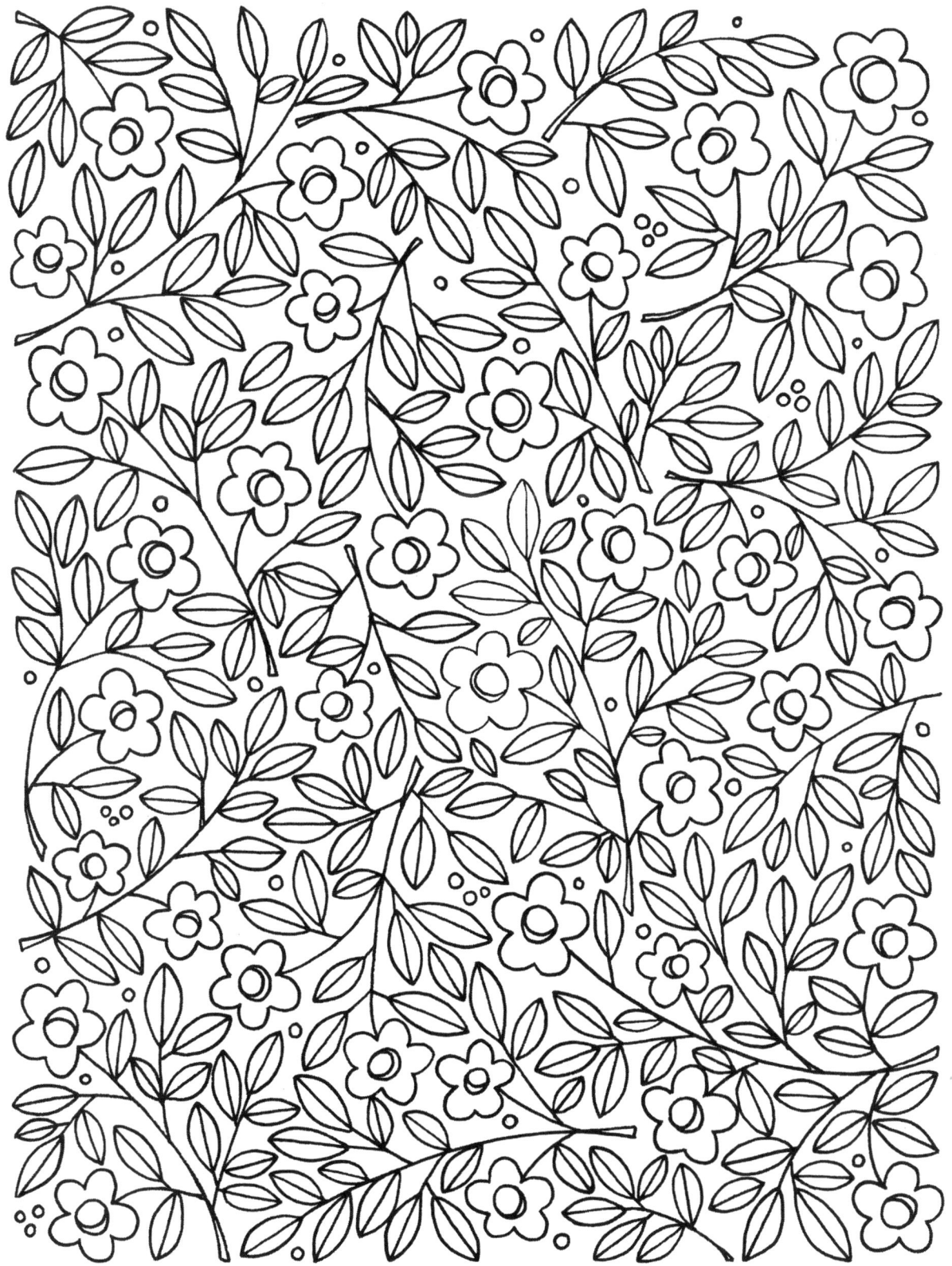

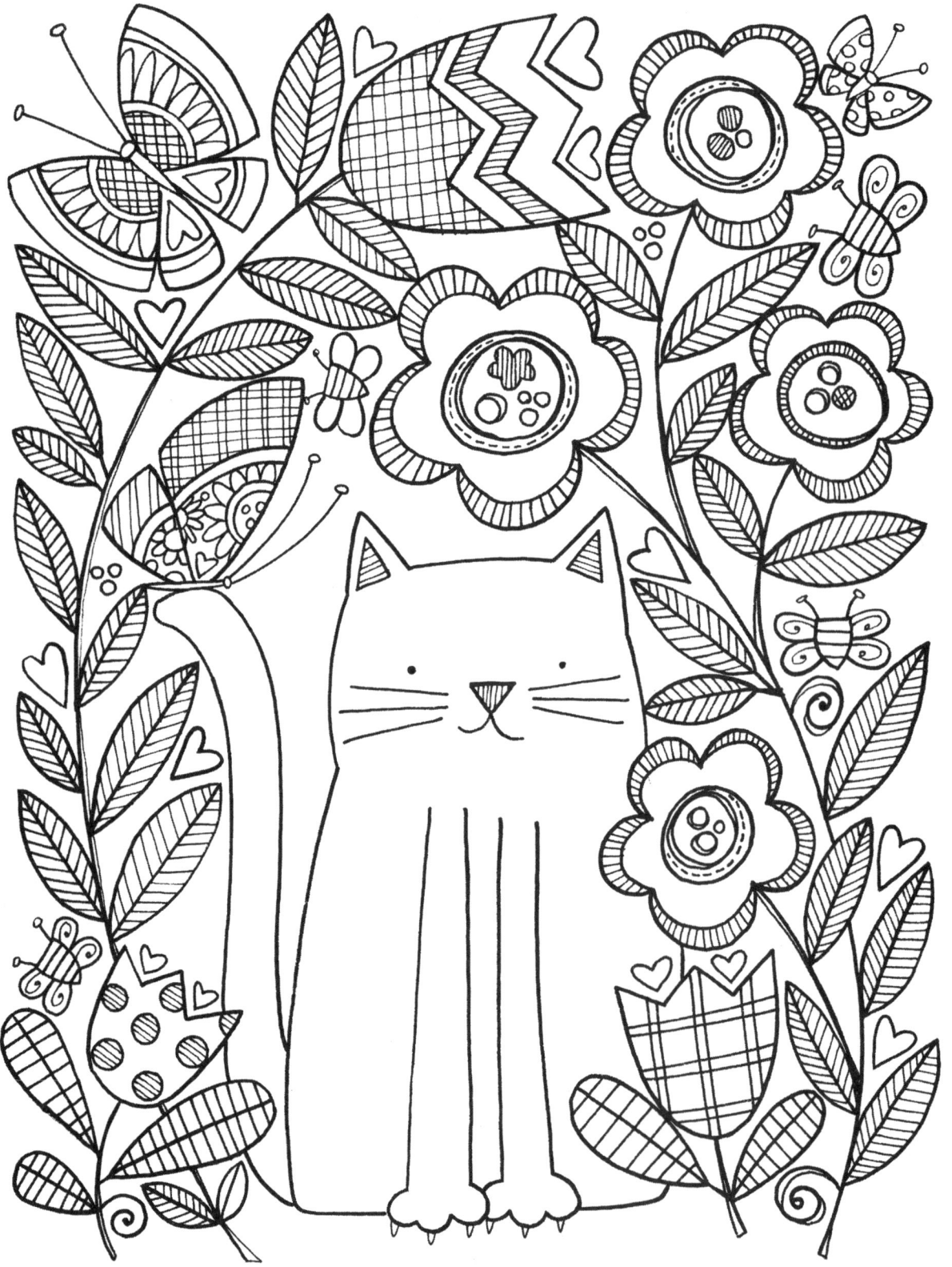

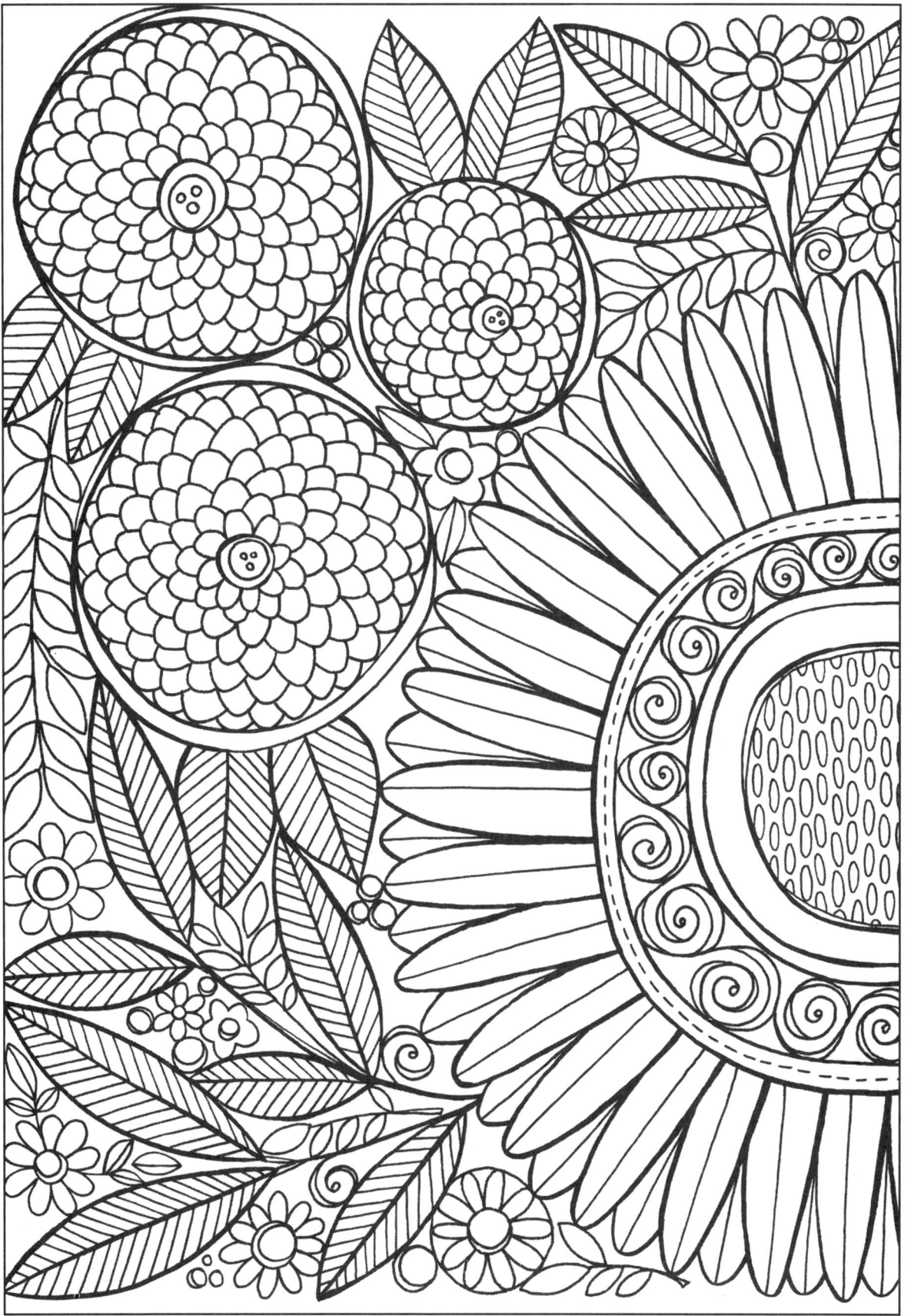

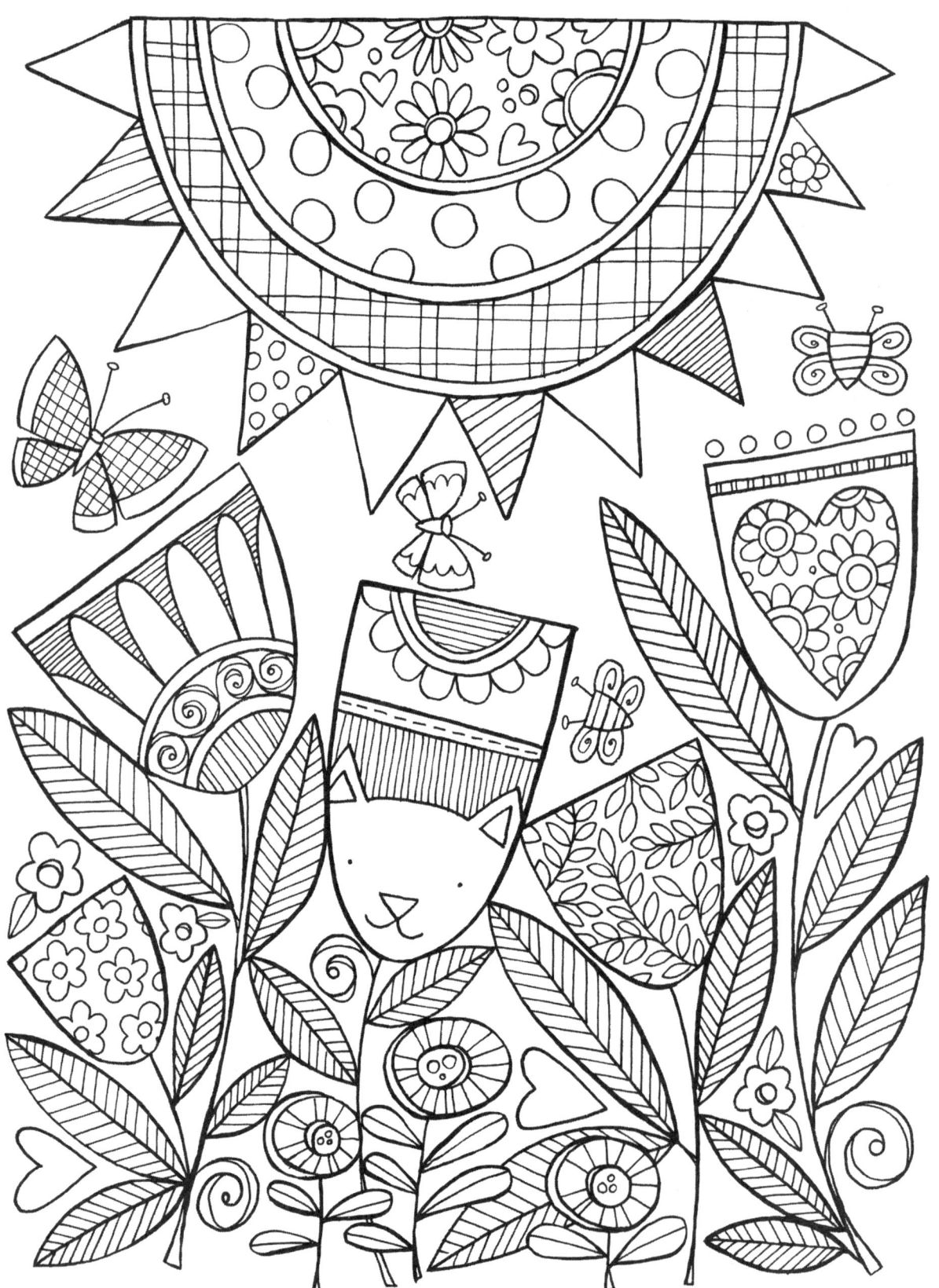

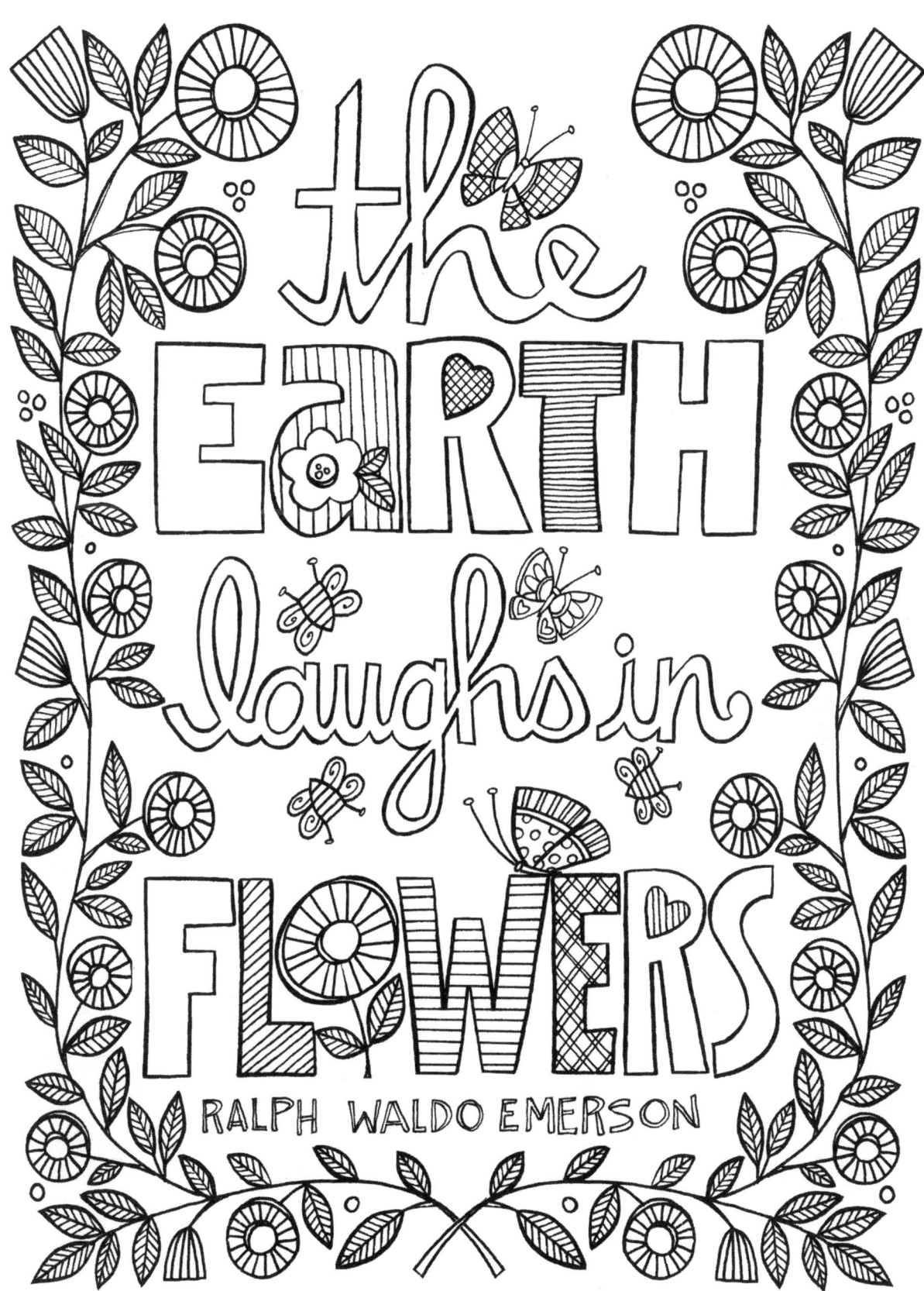

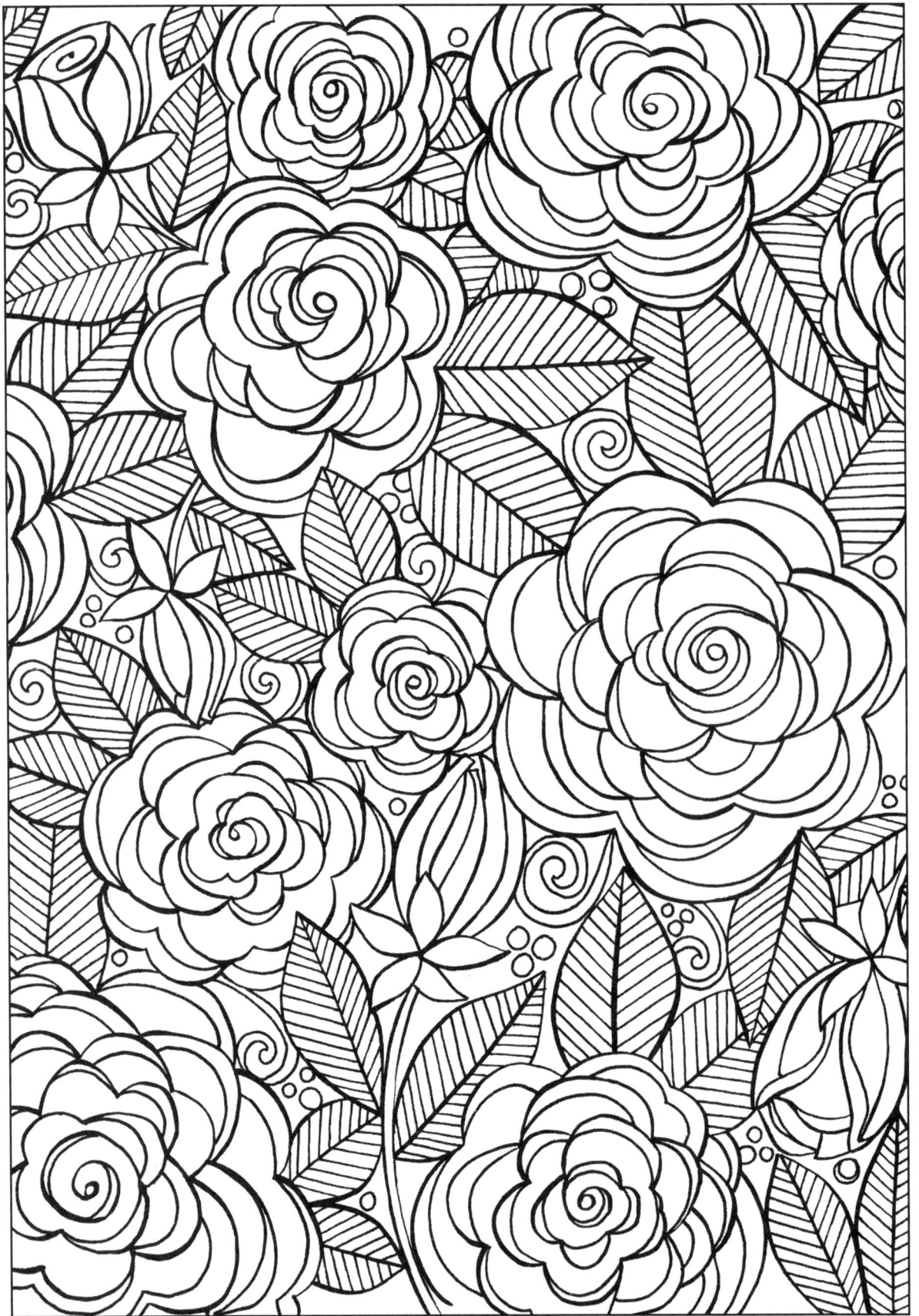

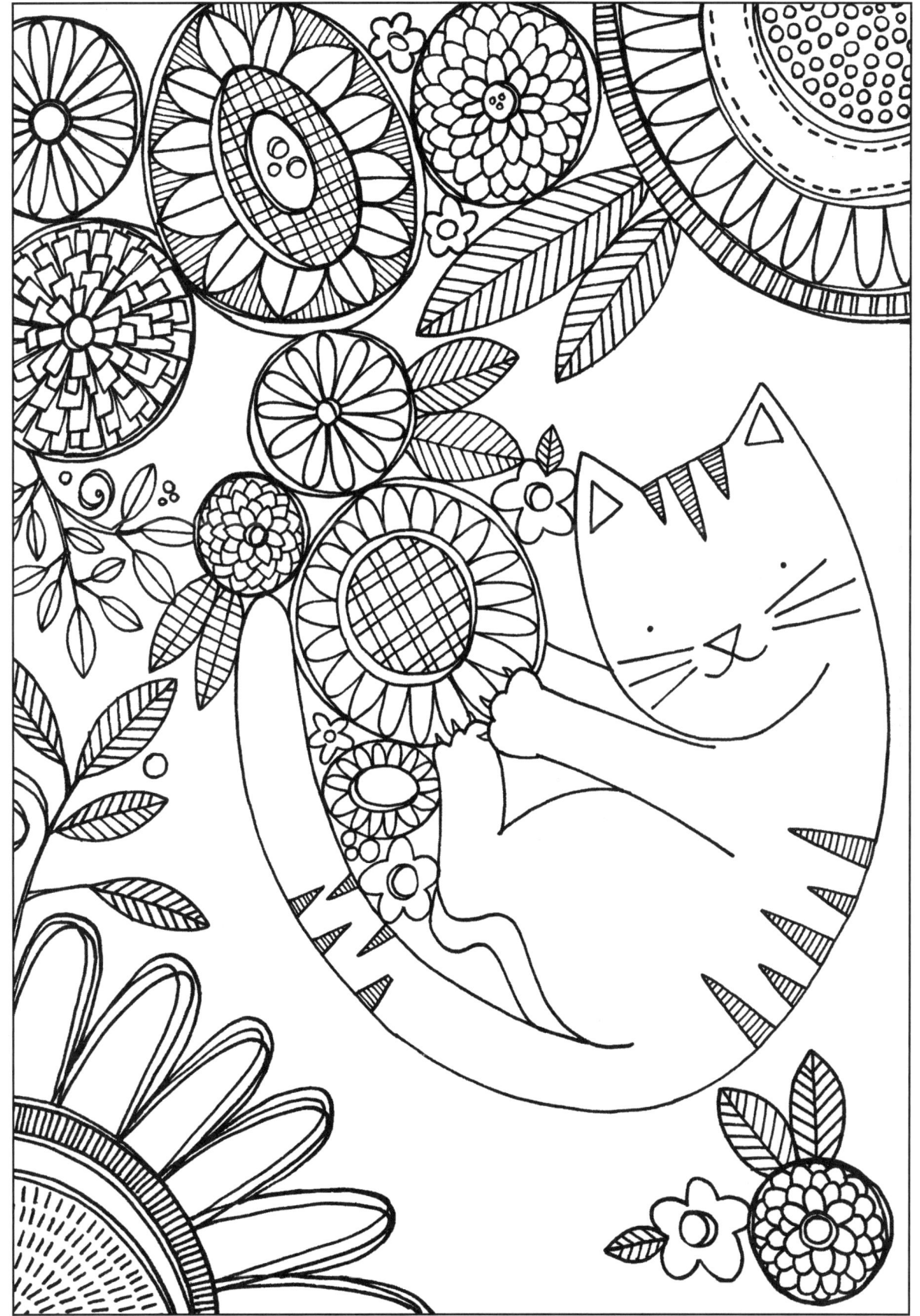

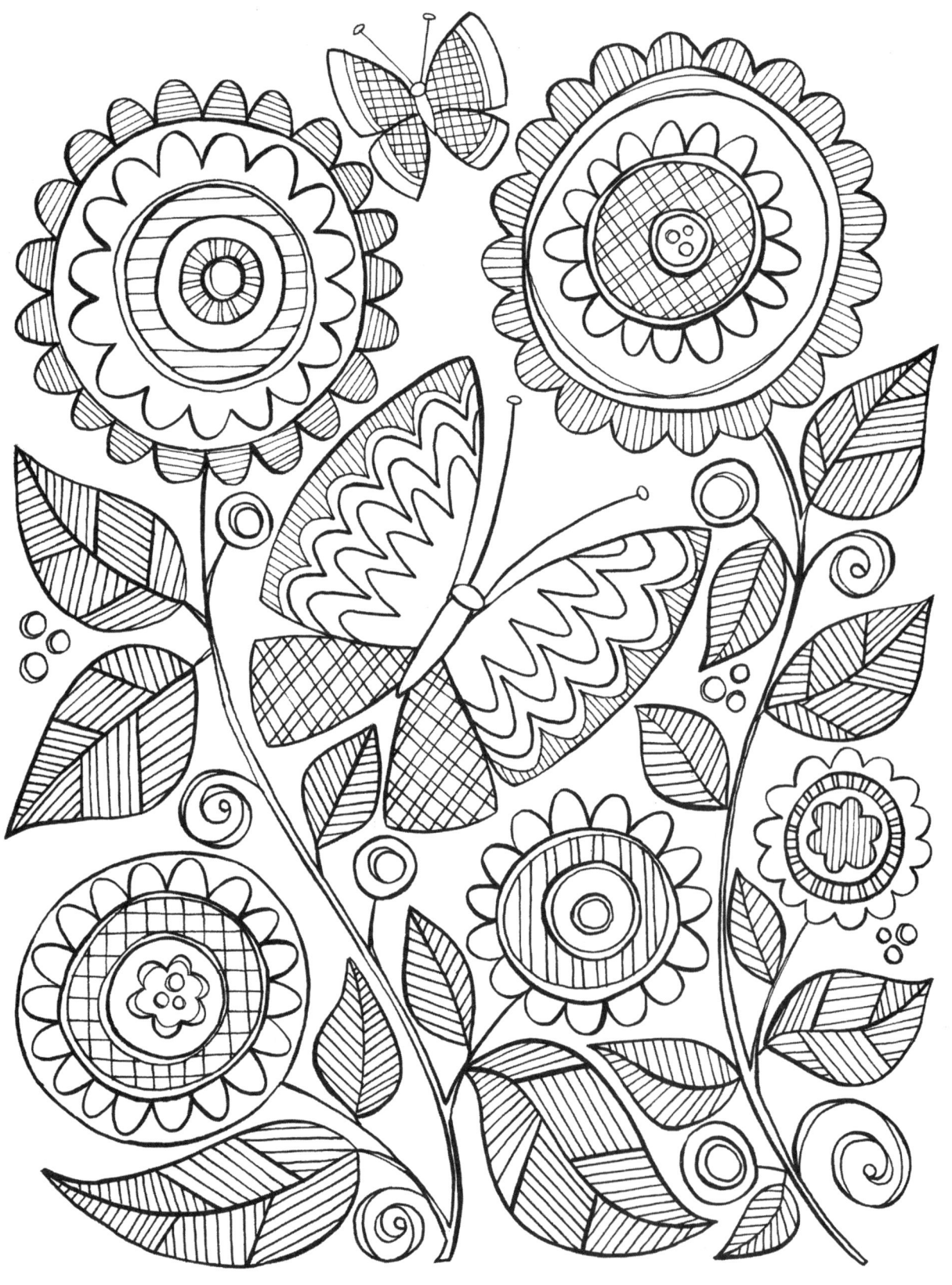

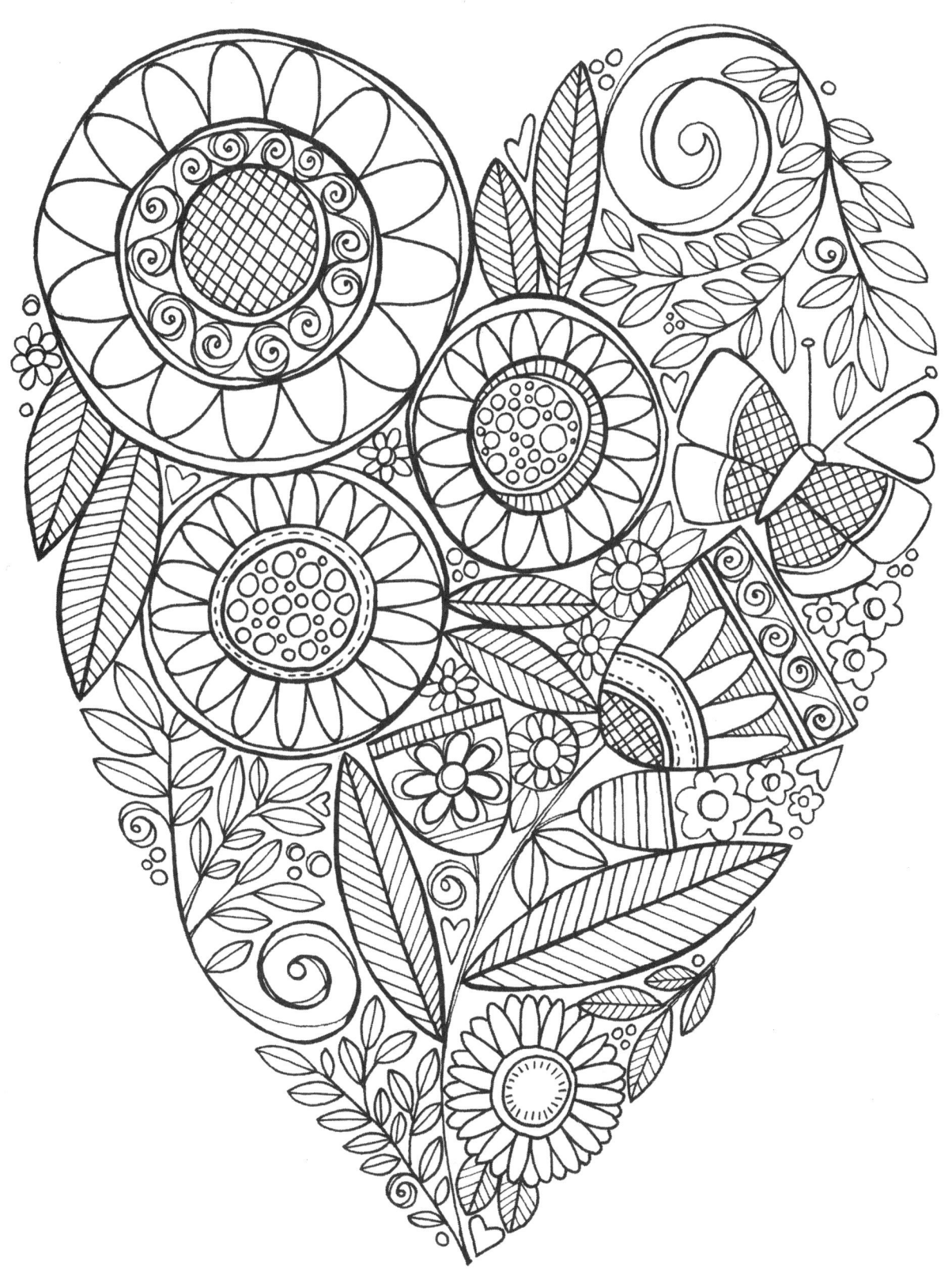

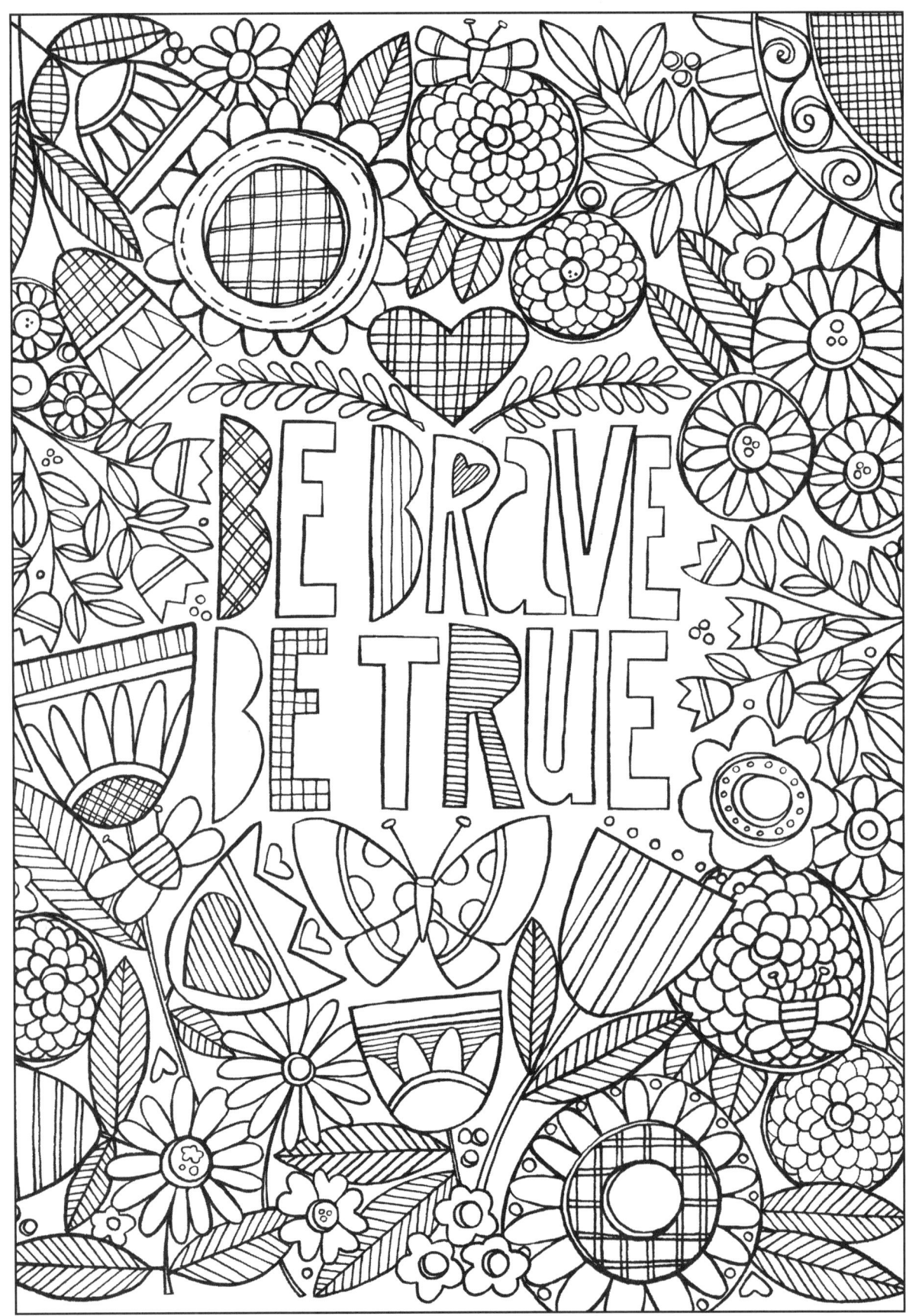

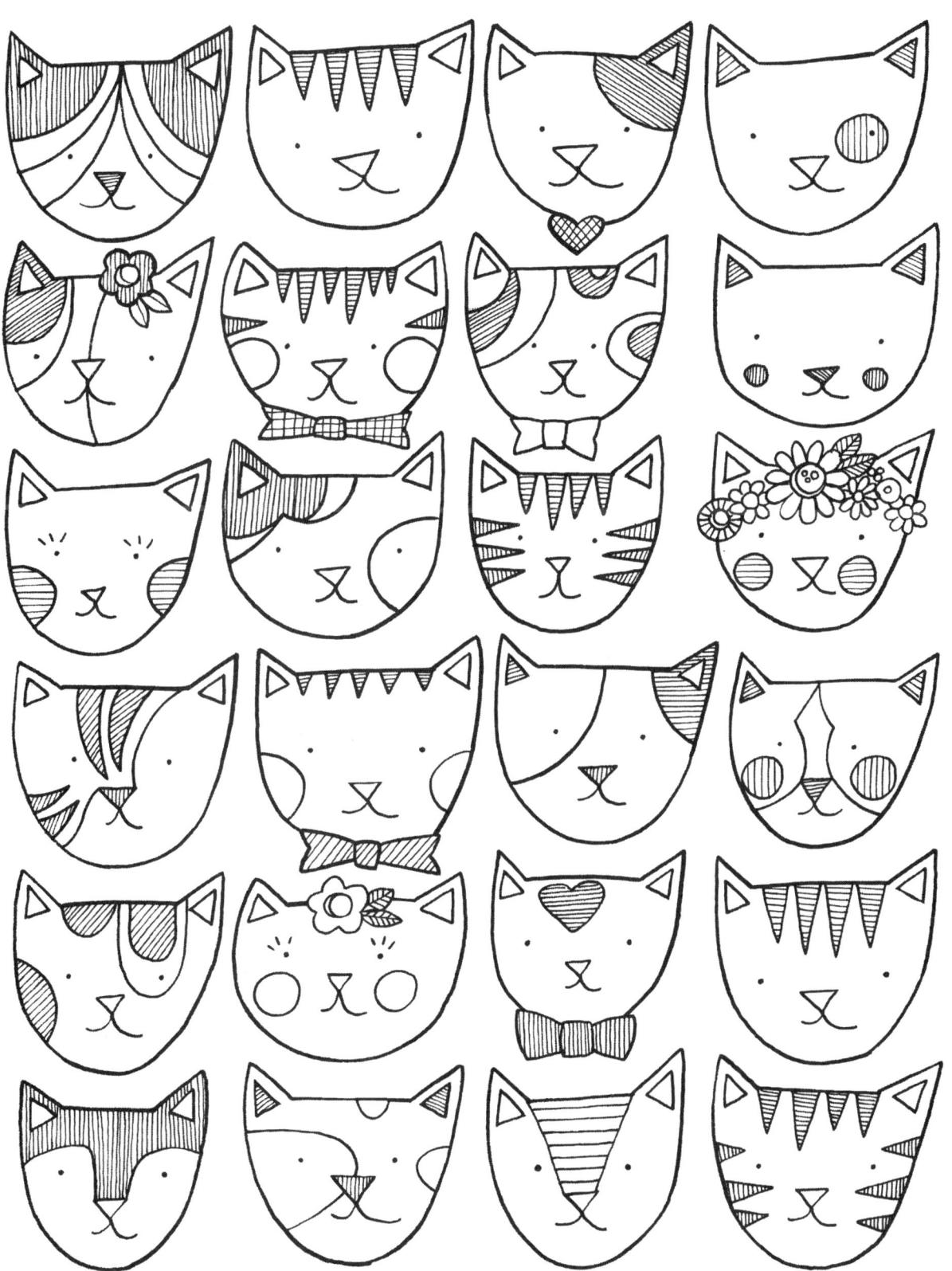

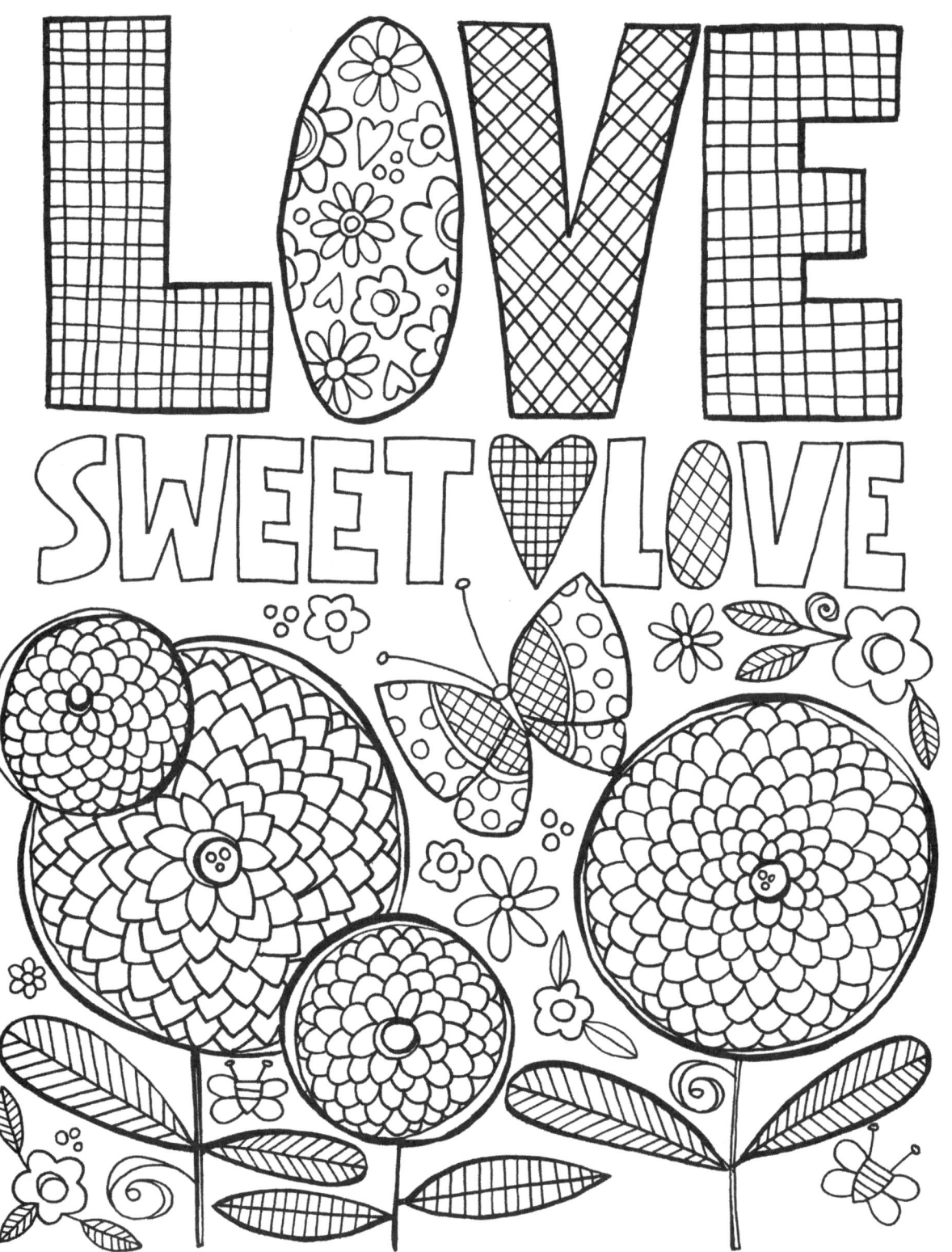

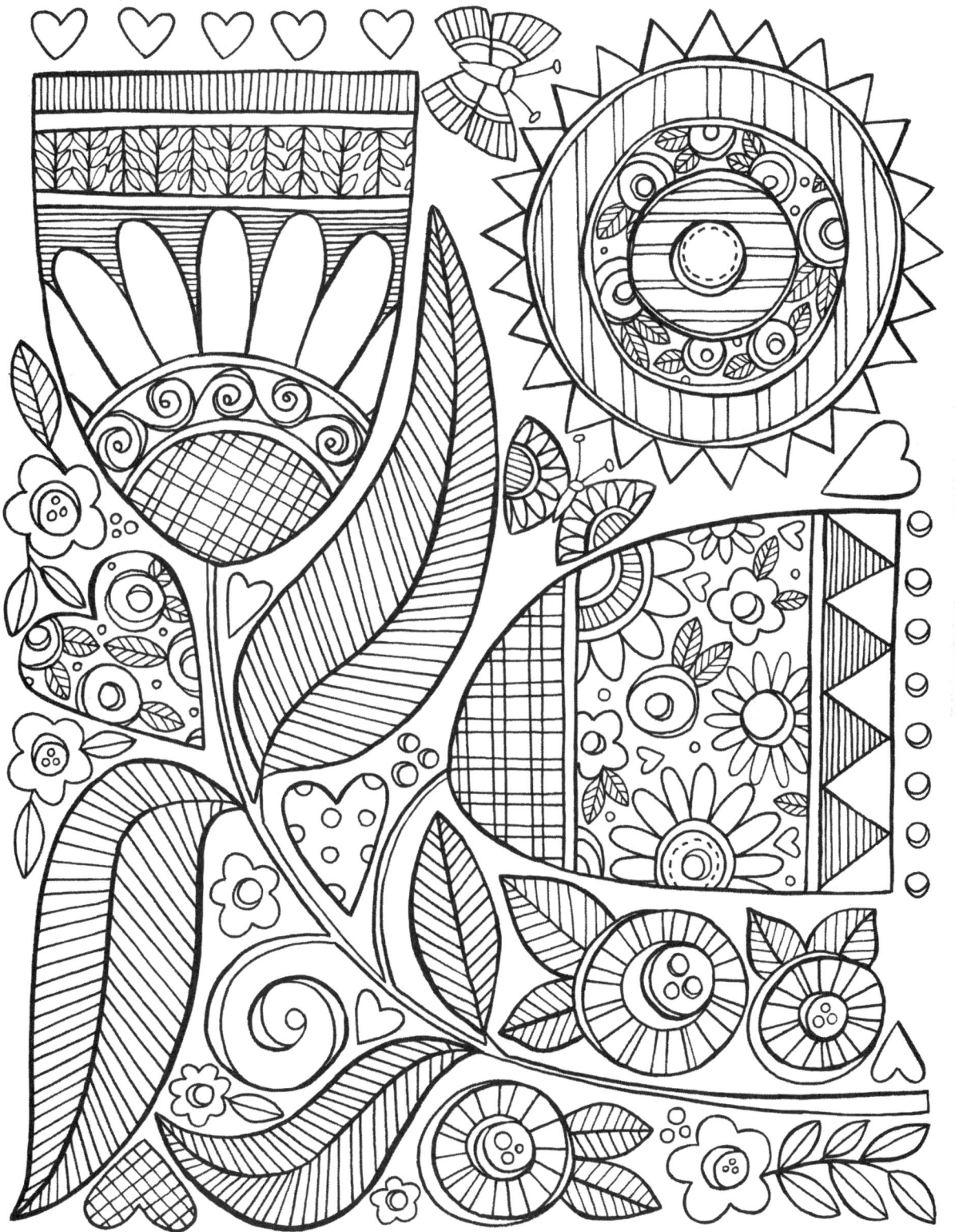

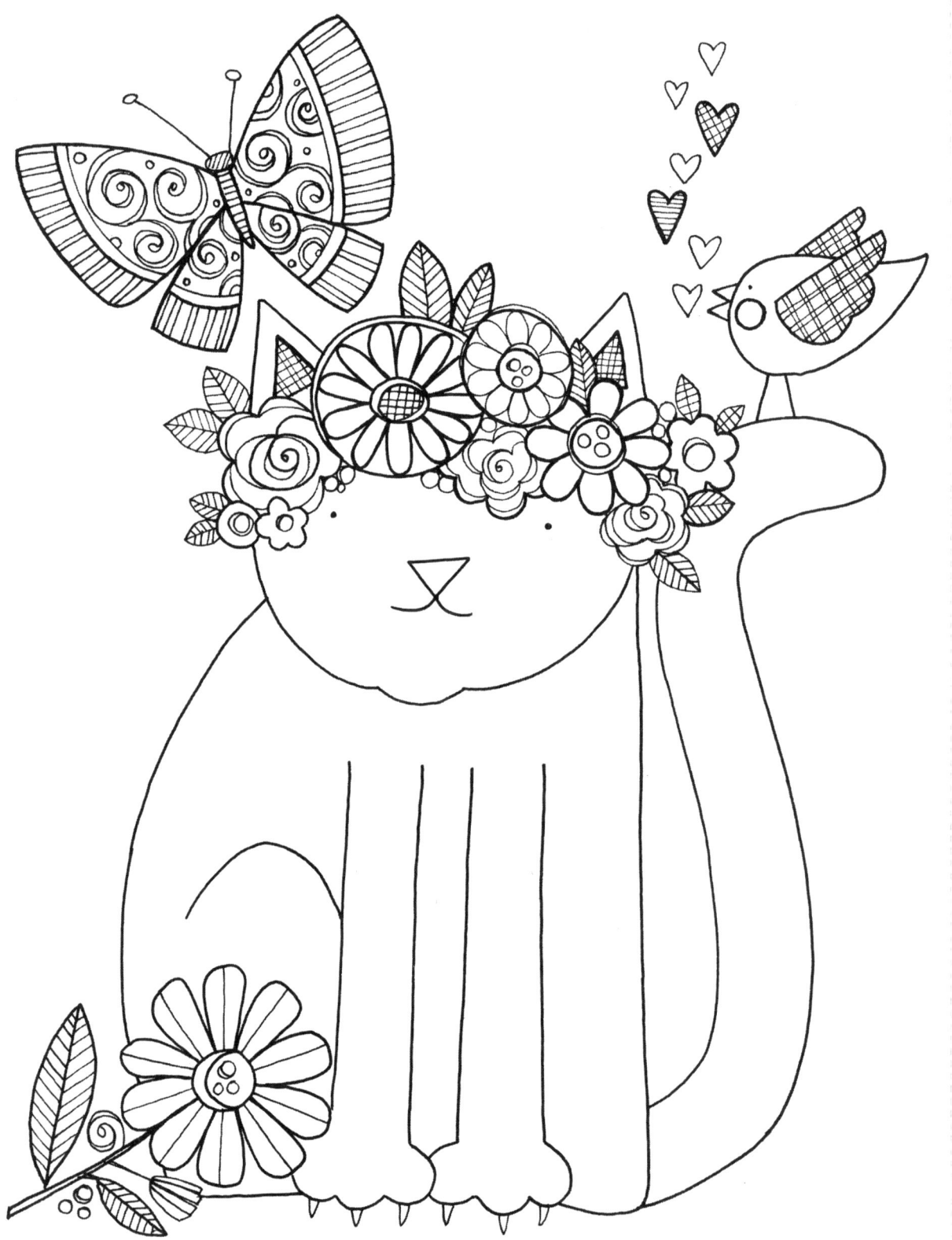

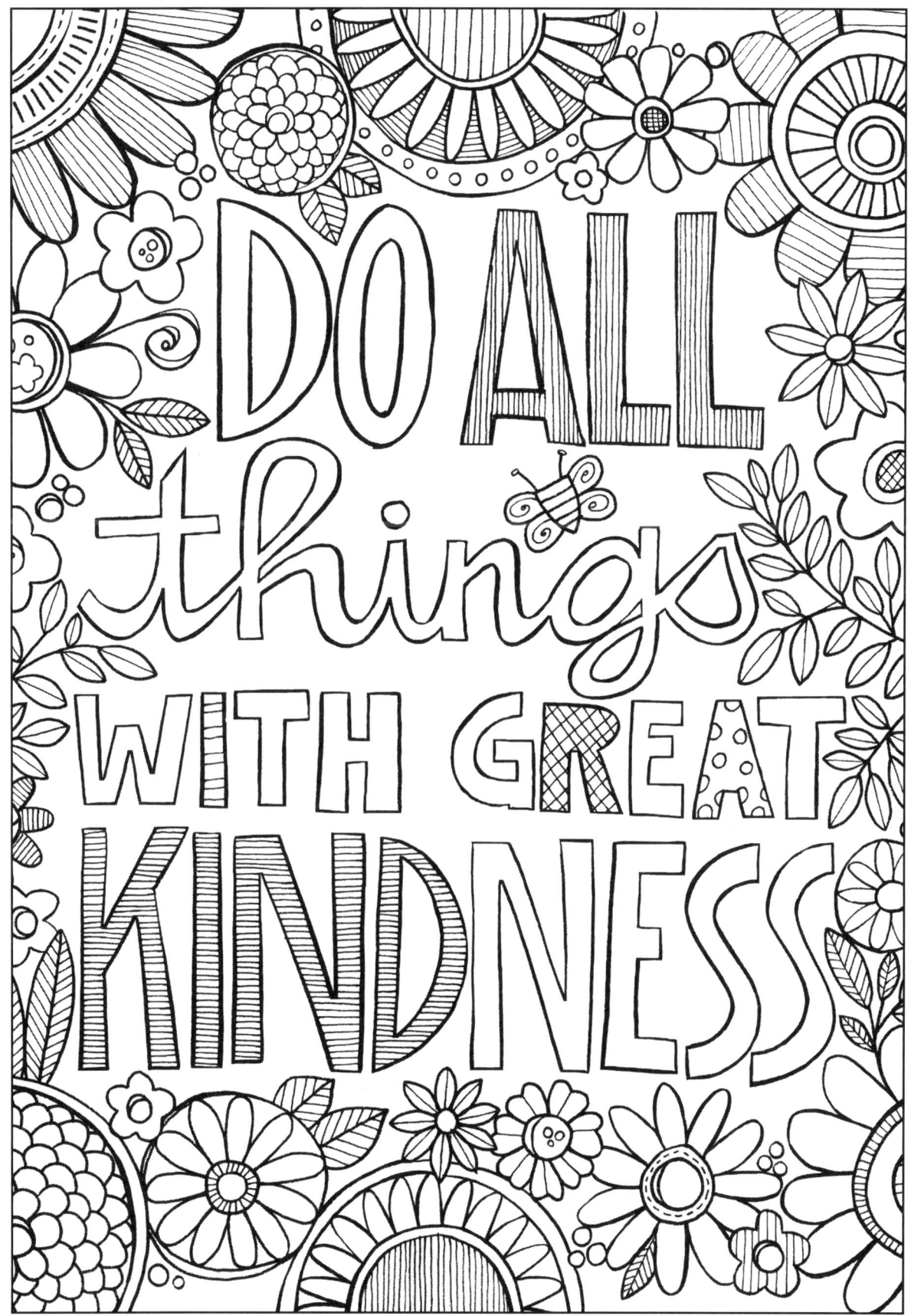

ALWAYS DO WHAT YOU ARE AFRAID TO DO

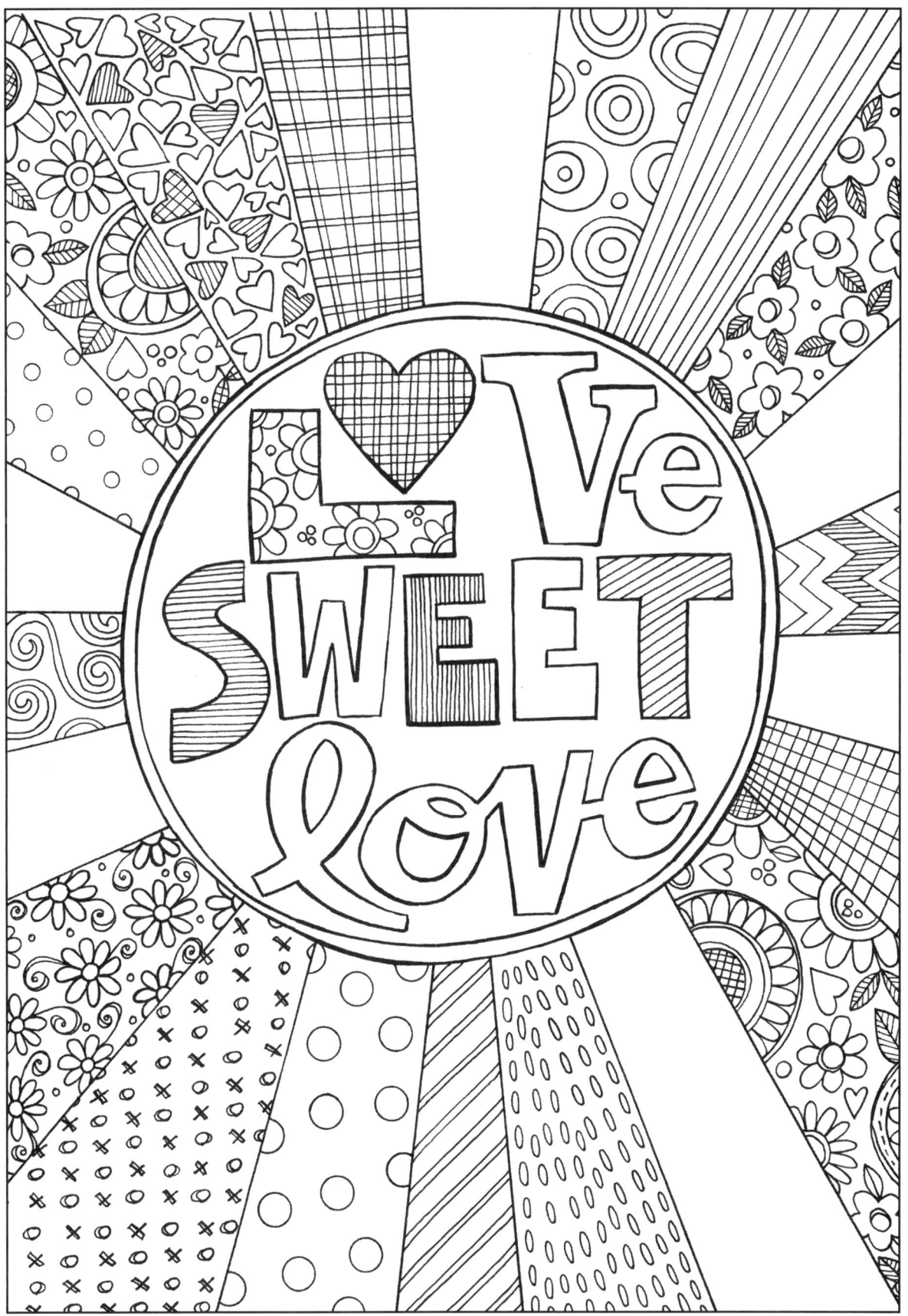

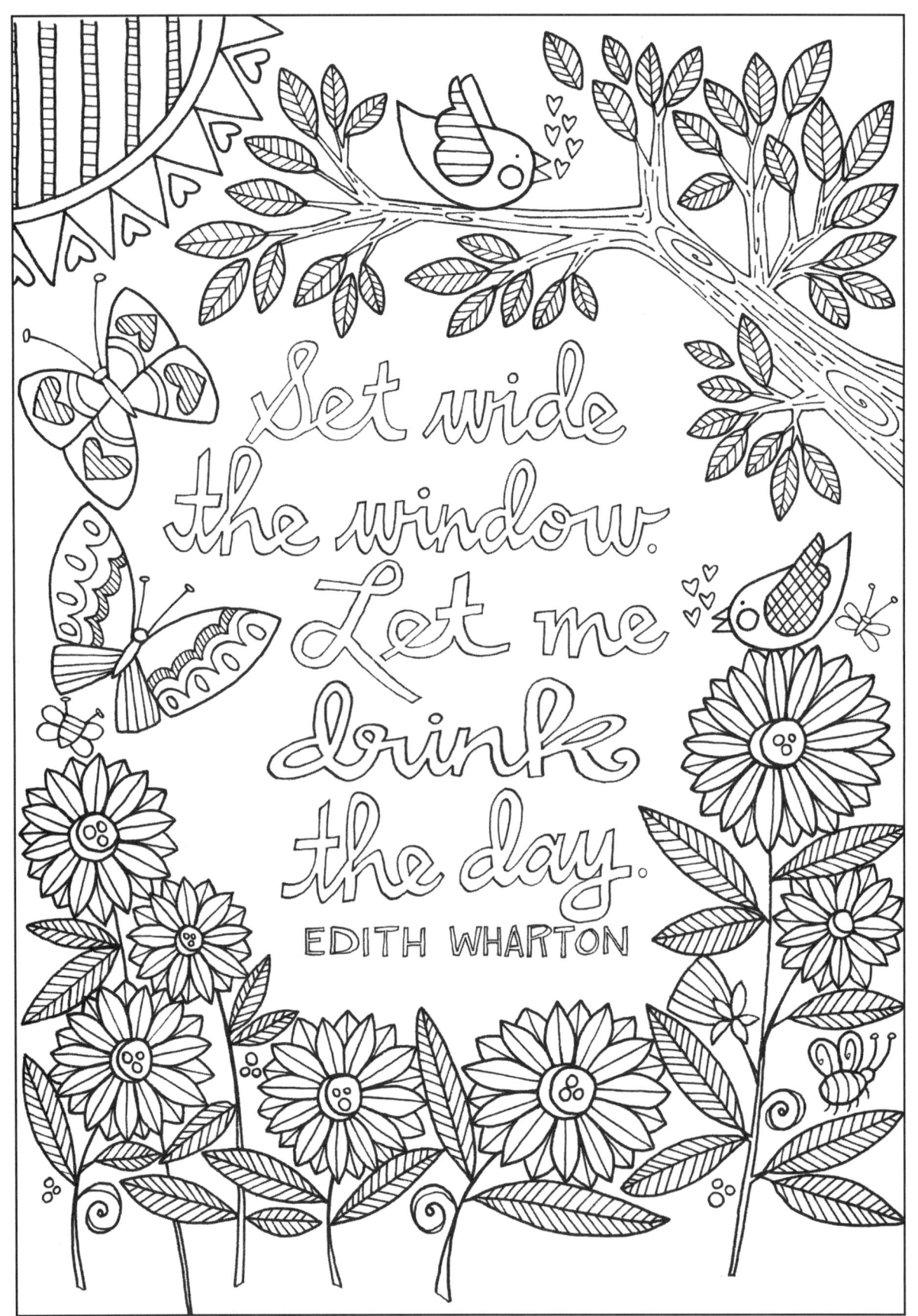

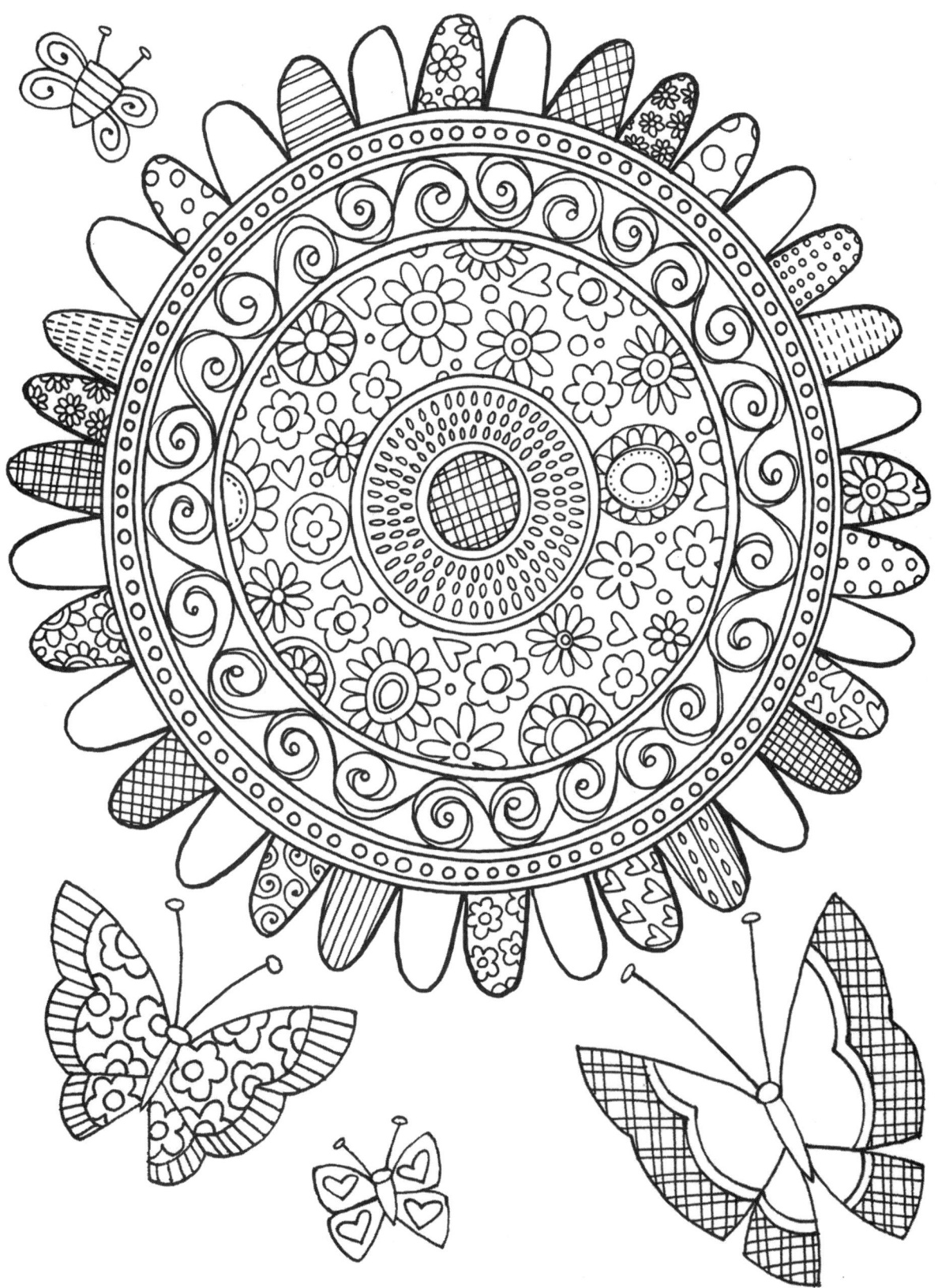

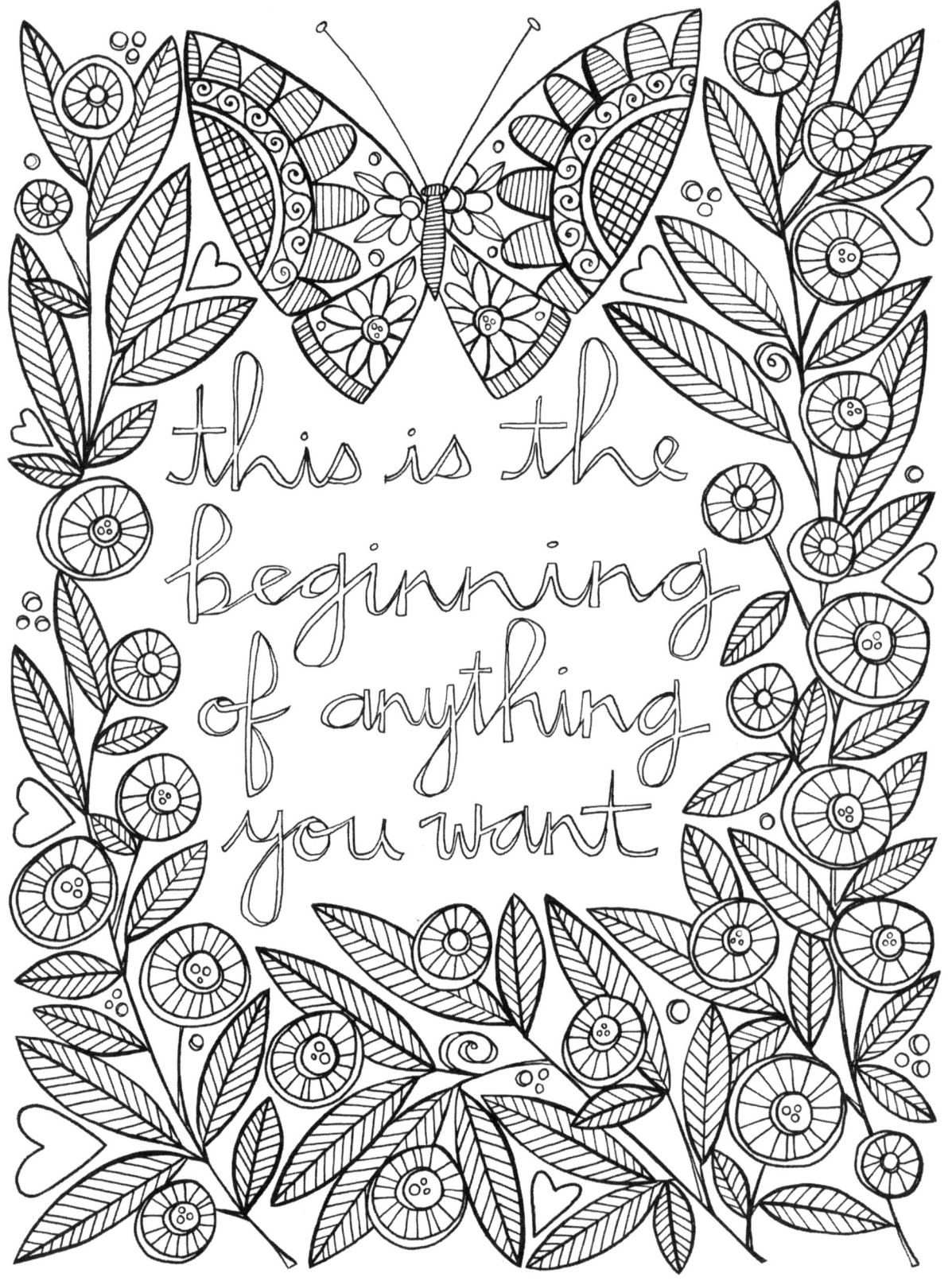

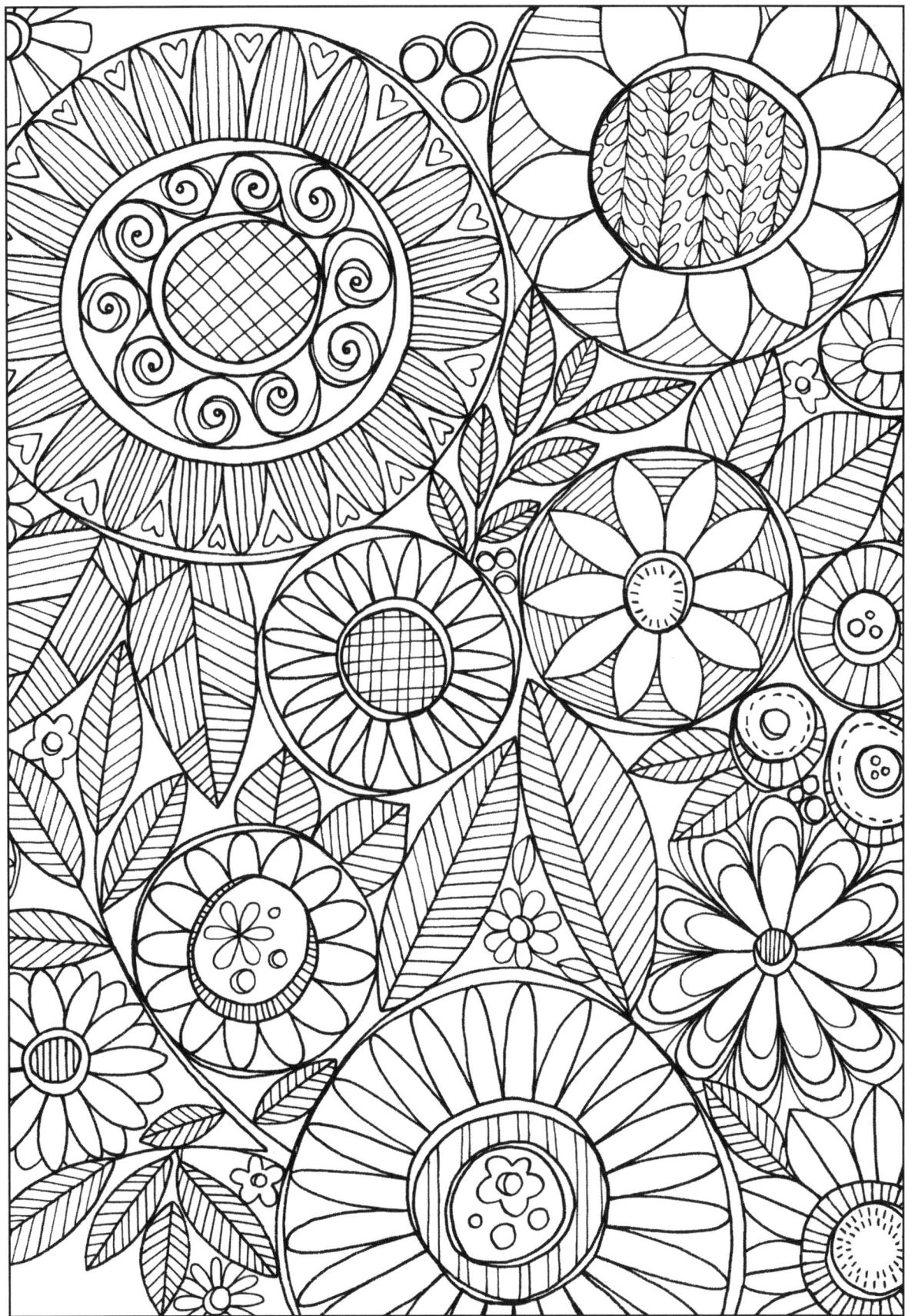

MY BEST FRIENDS EAT SUNSHINE

BETRUE
TO WHO
YOU ARE

"WHERE FLOWERS BLOOM, SO DOES HOPE."

— Lady Bird Johnson

BE BRAVE
BE KIND
BE TRUE
BE YOU

CHIN UP BUTTERCUP

love

BELIEVE in you

Believe
Be L♥ve

happiness is CATS, cats, FLOWERS & CATS

HOME is where MY CAT IS

cats + flowers

COURAGE, dear HEART

live in SUNSHINE

PLANT *Lady*

BLOOM BOLD & BRIGHT

there are no ordinary cats
—Colette

CAT CRAY CRAY!

CATS *and flowers* FOREVER!

Shine on!

FLOWER LOVERS

JOY delights in JOY

BLOOM BABY BLOOM

love

flowers are the music of the ground

EDWIN CURRAN

THANKFUL!

LIFE ✓ so much! IS BETTER WITH a CAT

LOVE

NEVER CUT WHAT YOU CAN UNTIE

FLOWERS & CATS

all things bright & beautiful